Transitory Gardens, Uprooted Lives

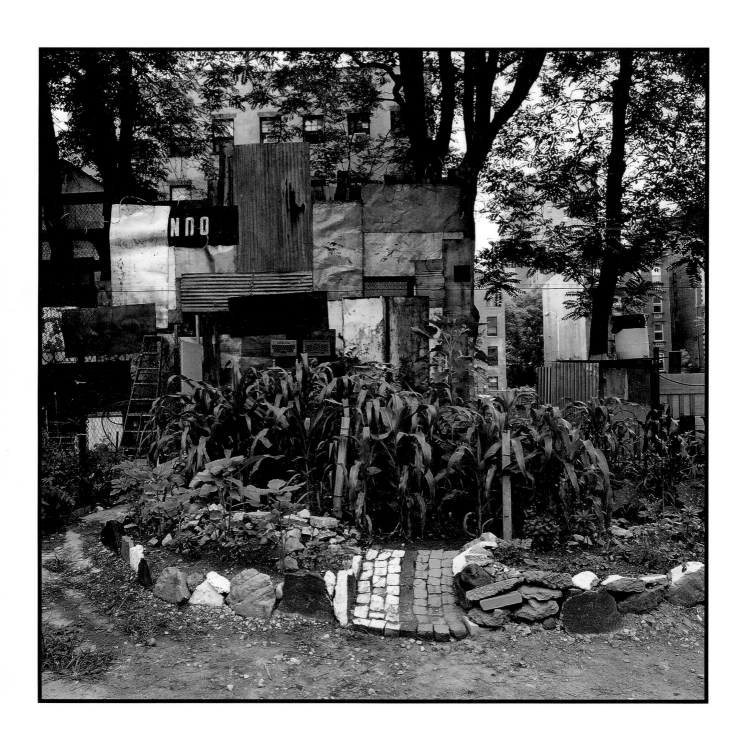

Transitory Gardens, Uprooted Lives

Diana Balmori and Margaret Morton

Yale University Press New Haven and London

This project was supported in part by a grant from
National Endowment for the Arts, a federal agency.

Library of Congress Cataloging-in-Publication Data
Balmori, Diana.
Transitory gardens, uprooted lives/
Diana Balmori and Margaret Morton.
p. cm.
ISBN 0 - 300 - 05772 - 5 (alk. paper)
1. Homeless persons' gardens — New York (N.Y.)
2. Gardens — New York (N.Y.)
I. Morton, Margaret. II. Title
SB457.4.H64B34 1993
712'.2' 086942 — dc20 93 – 4419 CIP

A catalogue record for this book is available from
the British Library. The paper in this book meets
the guidelines for permanence and durability of the
Committee on Production Guidelines for Book
Longevity of the Council on Library Resources.

10 9 8 7 6 5 4 3 2 1

This book is dedicated to the uprooted individuals
who have tilled the streets of New York City
in search of a home and, in the process, have laid
bare the meaning of garden.

Table of Contents

Most of the gardens documented in this book have been destroyed. For others destruction is imminent. It is the authors' hope that this more permanent record will bring attention and understanding to the homeless individuals who made them.

At the same time, the emphasis of the book is on the need and ability of the garden makers to create under extreme circumstances. The gardens made by the homeless have a tenuous existence, so tenuous that some could be recorded only once before they were demolished. A transitory nature, it soon became clear, was the very essence of these gardens, and their documentation was therefore driven by a sense of urgency. In the process, however, the authors also saw an opportunity to expand the historical record, which has always portrayed the garden as the domain of settled or prosperous individuals only.

This book is intended not only as a document of gardens made under difficult conditions but as an acknowledgment of the work of individuals and their powers of survival and creativity.

Diana Balmori and Margaret Morton

The Collaboration

Transitory Gardens originated in the fall of 1991. Margaret Morton had been photographing the dwellings of homeless individuals and tape recording their oral histories since 1989 as part of an independent project, *The Architecture of Despair*. She shared the photographs with her longtime friend, landscape scholar and designer Diana Balmori, who suggested a separate work concentrating on the exterior spaces alone, for in them the very meaning of the word *garden* was being transformed.

New York/New Haven
June 4, 1993

Acknowledgments

We would like to thank the following individuals who contributed to this book:

The garden makers inspired and sustained this work through their enthusiasm
and cooperation;

The National Endowment for the Arts funded the editing of the text and the
printing of the photographs;

Francesca Polletta assisted us with research, editing and discussion in the early
stages of the project;

Leslie Close, Kent Bloomer, John Hill, and Bonnie Yochelson wrote the many
letters of support that were instrumental to receiving the necessary funding;

Joanne Savio advised on photographic production;

Kathy Kennedy and her assistants, Sue Carbone and Kelly Grider, provided
photographic production for over three years;

Steve Zeitlin encouraged and advised the collection of the oral histories in the
early stages of the project;

Kai Erikson, Kim Hopper, Yolanda C. Knull III, William H. Knull III, and Jerald
Ordover advised on the oral histories during the project's later stages;

Jacklynn Johnson and Jacqueline Kessler transcribed long hours of audiotapes,
assisted by Judith Newman and Ted Panken;

George Mott advised on issues of photographic publication;

Joann Reese edited many drafts of the text;

Audrey Anderson and Hillary Quarles assisted with background research;

Denis Pelli, James Rodner, and Polly Wells helped us with discussions of the
book's title;

Jacqueline Kessler formatted the page layouts on the computer;

Barbara Glauber shared her computer expertise on many occasions;

Pam Smith supervised the book production in its final stages;

Lawrence Kenney at Yale University Press provided careful textual editing
of the final version;

Judy Metro, our editor at Yale University Press, greeted our initial proposal
with great enthusiasm and guided the book to completion;

Our friends provided a friendship that could bear our absence.

Transitory Gardens

We are calling the gardens of the homeless *transitory* in an effort to define them as a type of garden. But our definition has within itself a certain inaccuracy. The truth is that all gardens are transitory — more like our lives, less like architecture: we build them to give an illusion of permanence. In this way too they resemble our lives.

More than any other art, landscape is positioned in impermanence. This, in fact, is its strength, not its weakness. Gardens that are consciously and purposefully preserved may be, perhaps, more recreations than gardens. But even those landscapes that have a program of preservation built into them are ultimately subject to the limits of time, in that their living materials complete a cycle of life and death. Unlike buildings, gardens and landscapes are fleeting forms that live and die, though they do leave an imprint on their sites.

Here, in Margaret Morton's photographs of the gardens of the homeless in New York City, the reality of the transitory character of every landscape is evident. Ephemeral constructions — found objects arranged in found places — these gardens express a brief moment. Yet in many respects they speak of a desire for permanence or at least of an illusion of permanence.

It is in the necessity of their condition of impermanence that their interest lies. In this, they remind us of Japanese Zen gardens, in which seasonality and the fleeting image — a flower blossoming or a tree shedding its leaves — are central to its design. The gardens before us also confront temporality, although in different ways. The Zen garden, alone in landscape history, was created to acknowledge the momentary; the transitory gardens of the homeless only un-intentionally illustrate this condition. They are made and sustained under such uncertain circumstances that it is not known whether

they will last one month, one week, or one day. In spite of this uncertainty, however, they have been created with order and purpose.

Historical records have always favored the gardens of the wealthy and powerful, who can preserve or document their gardens. Long identified with affluence and ease, these gardens provide a place for leisurely enjoyment, private retreat, contemplation, and social interchange. The variety of these activities, in fact, even serves as a clue to the use of the garden as a space for regeneration and life. These are gardens that have been maintained over time, gardens for which drawings and plans can be found. They are also the gardens that get recorded in literature, music, painting, and photography. Wealth allows for both the making of the garden by a good artist, thus ensuring its survival on aesthetic grounds, and its documentation in other forms of art.

Gardens other than those of the wealthy have rarely left a trace. But there are some exceptions — those few gardens that have floated up through history in the line of a poem, the words of a song, or the fragments of a memoir: a small garden outside a medieval city wall; a monastery garden for healing those without any means; a garden leading to a Japanese teahouse, not more than a narrow corridor with a single tree and a few stones, whose very intent was to shun the use of anything costly. It is to these modest examples that we hope to add by capturing the image and material of gardens unique to our own time.

In *The Garden as Earthly Paradise*, A. Bartlett Giamatti presents the garden as a creation of hope and fulfillment; paradise is, in fact, the hidden paradigm to which garden making implicitly aspires. Giamatti suggests that after the Renaissance, the garden as an ideal nearly disappears in literature. While these literary

observations may be true, nevertheless, in itself the garden at all times has had an immanent power, waiting to be released by an act of creative will. This power remains constant but mutable, awaiting new interpretations.

It is of this power rather than of paradise that the gardens of the homeless speak. And they do so while connecting themselves, albeit tenuously, to Giamatti's definition. These gardens are not a part of the historical tradition in which the vestiges of paradise are embedded; they do not reflect the nineteenth-century picturesque model; they are not part of the family of gardens illustrated in popular magazines. Moreover, no lush, paradisiacal materials are available for their making. Constructed out of scarcity by persons whose basic needs — food, work, and shelter — are not met, they embody a sense of the precariousness and fragility of nature. Yet we cannot say that they lack a link with the mythic past of the garden or with its power. Few better examples of hope and the wish for fulfillment could be found.

While our book records the gardens of New York City inhabitants who, to say the least, have neither wealth nor leisure at their disposal, who have simply built gardens for themselves and have devoted time to them, it also presents a new way to consider the power of gardens. The study of the aesthetics of gardens traditionally has tracked the movement of motifs, ideas, and forms from the gardens of the affluent to those of the prosperous middle class to the parks and gardens of the public realm. Occasionally, garden design has been influenced by those short-lived, revisionist rebellions in the arts that point to folk art, naive art, or vernacular traditions as sources of inspiration for so-called high art. But here we should caution the reader: this book is not to be confused with one on folk or naive art (meaning that of unschooled individuals) or primitive

art (meaning that which does not come from historically dominant cultures). We think it important to disassociate these labels, which are often useful in other circumstances, from this work. The point of looking at these gardens is not to identify the artistic category to which they belong: it is to bring to light *compositions* made in open spaces, compositions that have been constructed from a variety of elements and that, through their detachment from the usual conditions in which gardens are made, liberate the word *garden* from its cultural straitjacket and validate the temporal, the momentary, in landscape.

As we consider these gardens, we will want to divest ourselves of any predisposition to a past critical framework. The romantic movement of the nineteenth century pointed repeatedly to the importance of *folk* and folk art as a way of including work other than that of a schooled elite. But unfortunately, it equated folk and the communal folk spirit with anonymity. At the same time, the romantic movement established the myth of the romantic genius, a very specific, individualized creator. By its very nature, this myth closed doors. Those who were not part of the educated elite, those from the underclasses and women, were all excluded.

What is most questionable about the myth of the romantic genius as it has come down to us is its lack of attention to the sources and process of creativity. These aspects of creativity are little understood, and current education has not had much to do with them; certainly professional design education has dedicated no time to such essential matters. But the desire to create is irrepressible and is a part of everyone, irrespective of social class, race, or sex. The importance of these two observations must be underscored. They are relevant to this book because we are still very much influenced by the ideas of the romantic movement: when we look at the gardens before us,

we will be pushed by this historical framework to regard them as anonymous or folk creations and to dismiss them as the work of indigent or unschooled individuals. If we do so, we will miss what is important about them.

On the other hand, this book is not a sociological study. Although the life of individuals living on the street is an expression of our times and our society, the meaning of which we cannot avoid, it is not our subject: we are not considering the gardens of the homeless because they are a part of that life. Rather, we are looking at gardens that happen to have been made by homeless individuals. It is possible that these gardens express only too well painful social conditions, their power lying both in the words which their makers use to describe them and in their visible form. But ultimately what the gardens show is a creative response to today's conditions. The gardens of the homeless speak, therefore, of us, and not of the nineteenth century. In their every aspect, they present a new material, a material emerging for our time. And they announce themselves at a time when we are seeking social and aesthetic redefinitions of the way to use and design open space.

We may be witnessing a resurgence of the garden itself. The garden's demise as a significant space or form has been declared repeatedly in this century, particularly since the Second World War. But the activity in just one small area of New York City, a city under great duress at present, contradicts this declaration. Perhaps the use of the word *demise* may be a matter of perspective. The color graded, English perennial border of house and garden magazines, a garden for viewing only, a garden of plants only, may in fact have lost its meaning as space and form. All of its bases have disappeared: a nineteenth-century notion of domestic life, an inexpensive labor force, a craft approach to garden making. The kind of garden

that is based on these premises, though still being built, does not correspond to the way we live, and it can only reflect the image of a past world.

We have purposely called these various exterior spaces gardens to express both the shift and the revitalization we think are taking place. The new gardens are not uninhabited green areas for viewing. They are spaces of active life, very small, not dominated by plants. They are filled with icons, toys, flags, and also the symbols of freedom and of nationality. At times, they are places of violence, danger, and death; and they are always ephemeral.

What they have in common is that they are urban, that they are made by society's poor, and, above all, that they incorporate found objects or salvaged, recycled trash. It is difficult to imagine how much work and time go into collecting materials for both dwellings and gardens from the trash deposited on sidewalks in the city of New York. This activity is done at night because most of the homeless feel ashamed to be seen rummaging through garbage cans and dumpsters and seek the cover of night to go hunting for their prizes. *Just the fear, can't explain it, just don't want to walk down the street, looking through the trash. Once you're drunk it doesn't bother you.* The residents of the East Village are accustomed to the sounds of this nocturnal scavenging.

The searches in the sidewalk garbage cans are long and arduous, and the materials found must be transported back to the site on foot. This must be done over and over again, in many trips. Materials are accumulated slowly, in anticipation of a critical piece, a prize find that will give a place character or structure or boundaries. Most precious of all are tools; the top find is a wrench, with which fire hydrants may be opened to yield water, the essential

commodity. But skids or pallets (wooden platforms used for the delivery of heavy materials) and plastic milk crates are valuable goods, too. Like the inclusions or references to living plants in these gardens — a single row of flowers at the entrance to a house or a mound of dry leaves — the use of these found objects is highly individualized: anything of possible value is taken up, and many things that do not seem useful are made so.

In the reuse of nearly everything discarded, the sparing use of water, and the economical treatment of space, these gardens speak the language of our time. We have been warned in no uncertain terms of depletion and waste. We are admonished to recycle, to conserve, to make maximum use of scarce natural resources. Here all of these admonishments are heeded by necessity, under extreme conditions, and the result is the elevation of such things as water and living plants to precious, valued elements. Ironically, it is through this necessity and the suffering underlying it that a respect for natural resources has emerged in these gardens.

On one level, transitory gardens show us how human beings transform their environment so that it can help to sustain them. On another level, they represent a new language, a language not yet clearly heard or one that may have been ignored because it speaks a different, even colloquial tongue. But each of these gardens contains an aesthetic element uniquely its own and represents, at its core, the individual's creative expression, the impulse that goes beyond education, economic class, age, and gender. The gardens illustrated here, pared of the superfluous, made with true economy of means by persons who are deprived of the most basic necessities, seem to point to the power of the garden laid bare. To us, they seem a testimony to the essential need for a garden: perhaps through them, we can learn again what a garden is.

Redefining Urban Gardens

Perhaps we are the first to apply comprehensively the name *garden*
to those compositions made by a sector of society not traditionally
associated with garden making. Yet it is likely that gardens such
as these have always existed, albeit in a sector of society whose
activities usually go unrecorded by history. Essentially, these exteri-
or compositions are gardens because they are so called by their
makers. These compositions differ significantly from traditional
gardens in that plants play only a secondary role in them, partly be-
cause of the movement of the garden makers from one settlement
to another, partly because of the difficulty of obtaining water. An
inventory of the materials of these gardens reveals that stuffed ani-
mals, toys, and finds from sidewalk trash cans replace plants as
important components. It provides the essential facts that help to
frame our definition: garden here is an exterior composition in
space consisting of recycled elements, requiring little expense and
maintenance, and creating an imagery that reflects the situation
of its maker.

While our book is an attempt to stretch the traditional definition of
the word *garden,* our effort is simply a reflection of what is occur-
ring in the cities around us, particularly in such places of vigorous
activity as vacant city lots. The homeless are just one of the groups
who have contributed to urban garden making on these abandon-
ed parcels of land: a variety of other efforts have also taken an
unexpected hold and are transforming the concept of garden. The
shaping of these outdoor spaces is the result of both legal and
illegal activities by the garden makers. In some cases, the makers
are homeless people, living and gardening illegally on a city lot.
In others, they are squatters who have taken over a building and
a lot illegally. They may also be legally housed tenement dwellers
who either take over an abandoned lot illegally or work in a legal
community garden. But whatever the character of these activities,

the sites are usually on the edge, outside our conventional definition of *garden*. We begin our book with an overview of these various enterprises, which can be categorized as community, appropriated, and squatters' gardens.

Community Gardens

The oldest and best-known of the urban garden-making efforts are community gardens, which have spread throughout the inner cities. Some of these gardens sit cheek by jowl with those of homeless individuals. Originally the initiative of individuals or communities, they have grown in popularity and have garnered the support of many city social organizations, which have begun new community garden efforts. As a result, government and social agencies, by providing the community with professional help in layout, design, and form, have shaped these gardens. Although many of the early community gardens were destroyed by the lot owners or the city because they were sometimes established by activities outside the frame of legality, of late their value has been recognized. The activities resulting in their establishment in the heart of large cities have begun to develop a literature: Sam Bass Warner's *To Dwell Is to Garden: A History of Boston's Community Gardens* is a recent example of the interest in such gardens in a large American city.

When a garden in New York gains the city's blessing, its users usually gain access to Operation GreenThumb, a city agency. The small size of the plots, their low cost (a lease costs one dollar a year), and access to horticultural help ensure that many such gardens come to fruition. Profuse in their greenery, they provide individual and distinctive spaces for those who choose to tend them. Notwithstanding the benefits to garden makers — legal status and access to such assistance as horticultural expertise and advice and the occasional loan of tools and seedlings — some groups eschew association with Operation

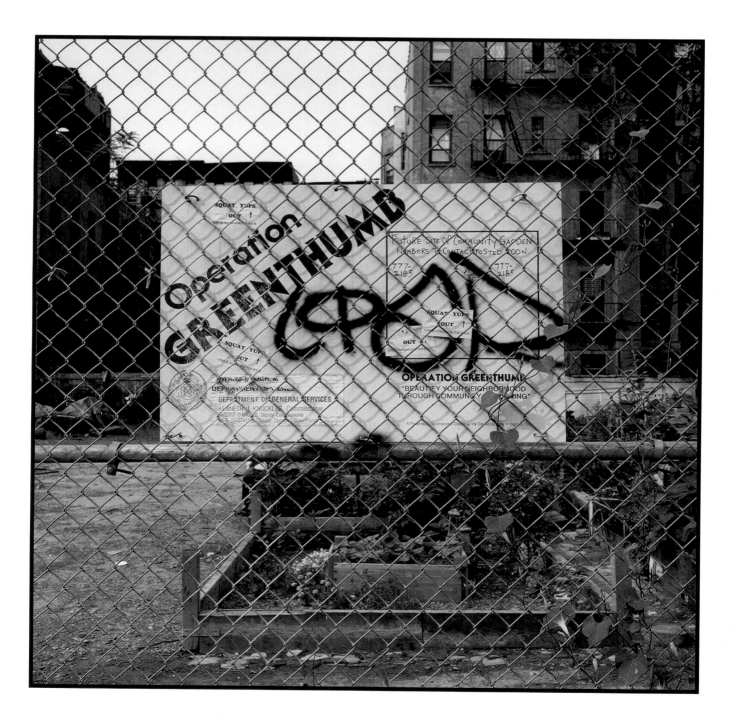

GreenThumb. These groups continue to make their gardens with no outside help, remaining independent of the social agendas and the laws and regulations that come with the governmental hand. The more interesting community gardens are those in which Operation GreenThumb has not become involved until after they have been set up. These are less homogeneous and have more distinct individual characteristics.

Community gardens soon acquire respectability and an air of permanence; indeed, they have a longer life than any other of the urban gardens recorded here. Moreover, a number of features distinguish them. First, the gardens are marked by their fences, which are usually high and locked. These are often chainlink, but sometimes of cast iron salvaged from an old building or a demolition. The garden fences also frequently have climbing vines, usually morning glories, which, like the ailanthus tree, the volunteer and survivor of urban lots, sprout in poor soil and survive with little care. Together with the fences, these cerulean blue, dark violet, or red purple blossoms are the most recognizable symbols of the community garden. Other features — water, herbs, benches, and paintings — mark these gardens and may be the work of an individual plot lessee. These, the personal marks of garden making, are always the most interesting part of community gardens.

Although community gardens have many individual features, they tend to follow traditional patterns in content and form and resemble traditional gardens more than any other kind discussed here. As a type they share some general characteristics: they have no lawns, they are densely planted, and they make extensive use of raised beds, a garden device that reduces the need for watering and weeding. Moreover, their organizers strive to maximize the number of individual parcels within the garden and by virtue of this usually

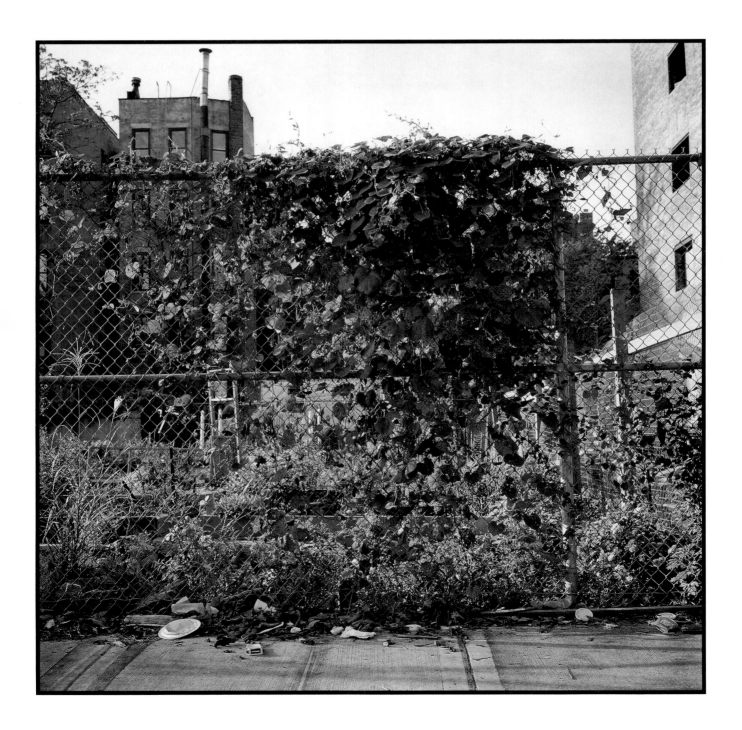

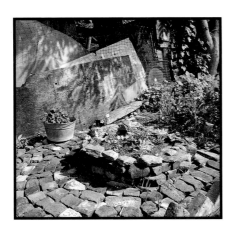

impose a very regular geometric order on most of the layout. Community gardens also tend to be productive, geared to the cultivation of food.

More important than the physical characteristics of these community gardens, however, is their social function. Spaces in which community members interact with one another, they weave people into a neighborhood and enable them to combat some aspects of urban anomie. Here gardening and garden making are activities that create a small, familiar, comprehensible, and livable community within the urban metropolis. The following two examples reveal in closeup how these gardens can work.

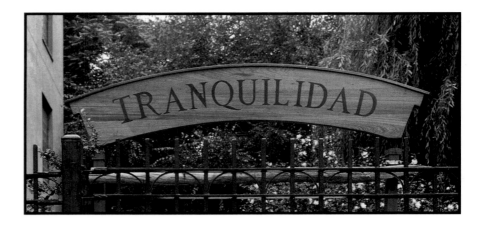

Tranquilidad

Tranquilidad (Tranquillity) is a community garden belonging to a neighborhood at 310 East Fourth Street. Tranquilidad came into being after the building next to it, the original homesteading building on the block, gained homestead status. The lot adjoining the building was piled six feet high with rubble. The residents in the homestead decided to clear the lot and make a garden in the hope that it would become a focal point for all homesteaders. Initiated by Anne Boster, Bruce Morris, and Trudy Silver, residents who were the garden's founders, the work was done by the building occupants with no outside assistance. Bruce Morris says of the process, *You have to have a clearly identified group to maintain the space before you can get status.* Support did come. After the rubble was cleared out and the space was made into a garden, Tranquilidad gained legal status and Operation GreenThumb help.

Tranquilidad is recognizable at a distance by its massive greenery and its tall cast-iron fence with locked gate; only those members of the community who join the garden have keys. Thickly planted, the plot recalls in its density a tropical garden more than one grown in a temperate climate, and it evokes the life experiences of its members, whose origins are Puerto Rican. There is an effort here to imitate a professionally designed garden: the cast-iron fence, the planting bed with low, rustic wooden rails on its borders, the garden path with granite paving blocks. Tranquilidad bears the mark of different hands: one participant has grouped three statues of robed Chinese men, setting them against a hanging white veil in a dark corner under shrubs. The statues are interspersed with stepping-stones; wire fencing protects them and keeps trespassers out. Another member has created a centerpiece of a small mosaic bird-bath with a red fish floating in a white and turquoise basin rimmed with mauve glass insets.

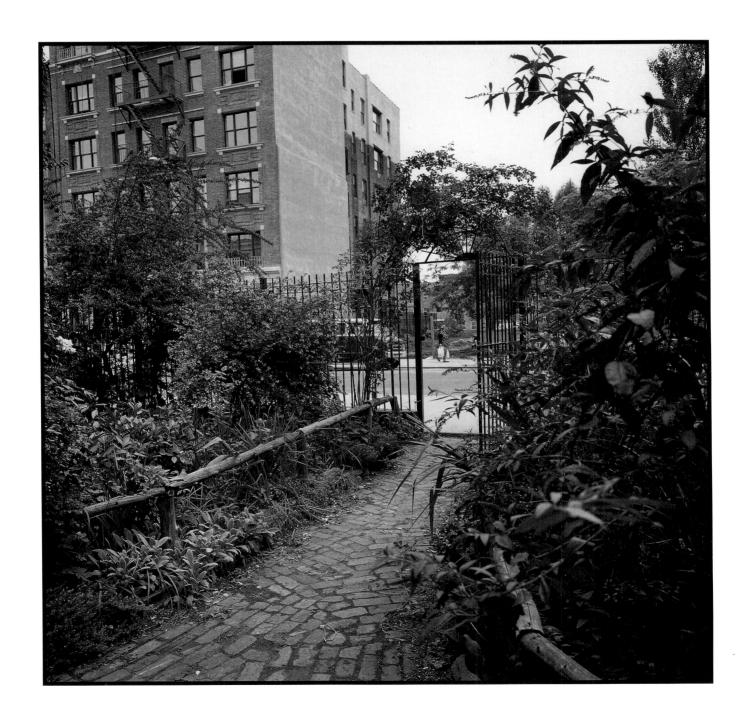

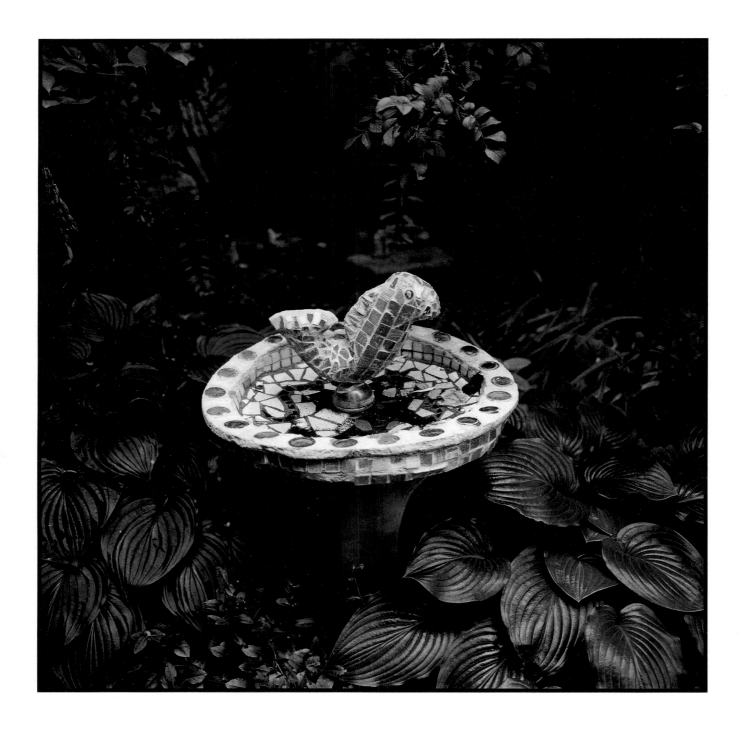

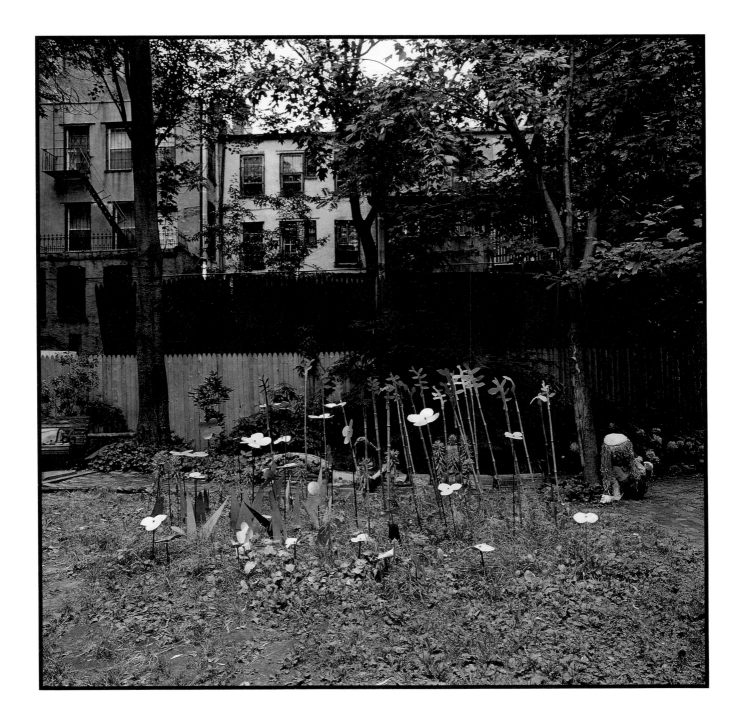

19 *Tranquilidad*

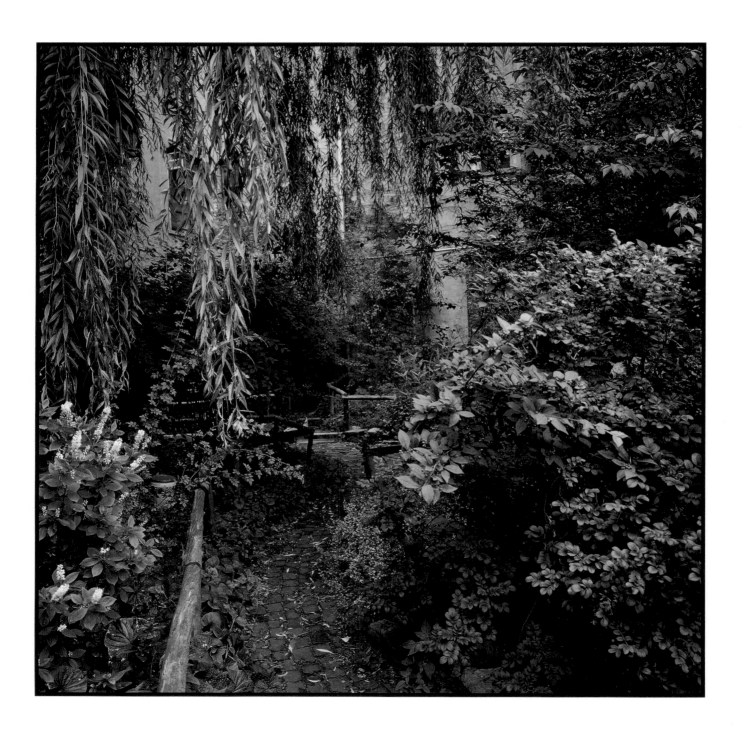

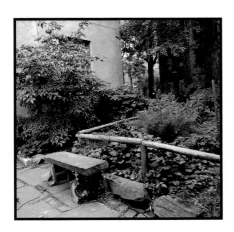

Tranquilidad is a shady garden, dominated by a huge willow and its long, weeping branches. At its back, shaded by the willow and other large deciduous trees, is a clear space. In this area, where little can grow, a large bed of brightly painted metal flowers has been placed. At first this mix of massive greenery and metal flowers is jarring. The planting pattern, the cast-iron fence and entrance gate, and the rustic wooden planters suggest a traditional garden composition, but the bed of metal flowers and half-hidden Chinese figures belie this impression. Tranquilidad is, however, a garden that very much serves the Spanish-speaking people who live in the buildings surrounding it. Its fastidious condition reflects the great attention and care lavished upon it. Producing no fruits or vegetables, Tranquilidad instead declares its purpose by its name: to give pleasure and tranquillity.

This officially designated community garden at Ninth Street and Avenue C centers on a lily pond, backed by a wooden pergola with a trellis and benches. At first glance it, too, seems to belong to the family of professionally designed parks and gardens. But if we look more closely, a frame of corn plants at one side and many other special idiosyncratic features catch us by surprise. Howard, who works in a flower shop on Fourteenth Street, made the lily pond, which is lined with black plastic, and stocked it with fish. In another part of the garden, Howard has made a small fountain, embedding stones and fragments of colored marbles in white cement. Its edges are rimmed with white stones and abalone shells, which are flanked in turn by small-leafed trailing plants. The bright, multicolored marbles, stones, and shells all sparkle against the white basin of the fountain in the sun.

In another section small, rough-barked pine trunks form an archway. Another of the leased plots is overgrown with tomato plants but also contains in its midst an urn planted with flowers. One gardener has constructed an overscaled picket fence to mark the edges of her raised planter and painted it white. The scale of the pickets makes a strong form in the garden. Of even greater interest is the sunken herb room made by Paul, another member of the community garden. The sunken garden is an unusual concept for a sitting space; most gardens are laid out in two dimensions. This small garden room, set down into the earth, is reached by six stone steps. The interior walls of the sunken room are brick, and against one of them a bench has been placed facing east, away from the street. In the late fall and early spring this is a warm, sheltered, even sensuous spot: seated at the bench, one can smell the perfume of the herbs, which have been planted on all sides just at head height. This inviting space within the garden is offset by the padlocked gate and high chainlink fence that surrounds the garden as a whole.

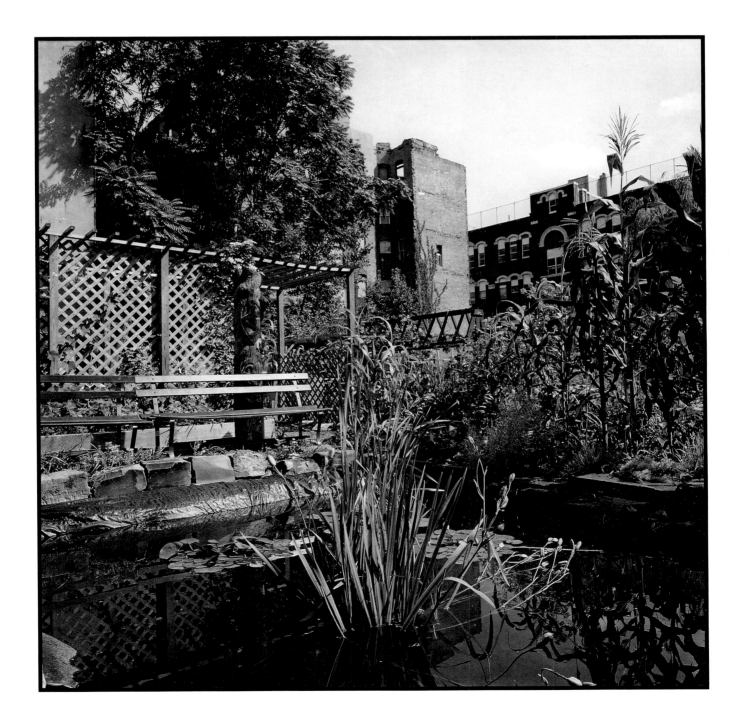

23 Ninth Street Garden

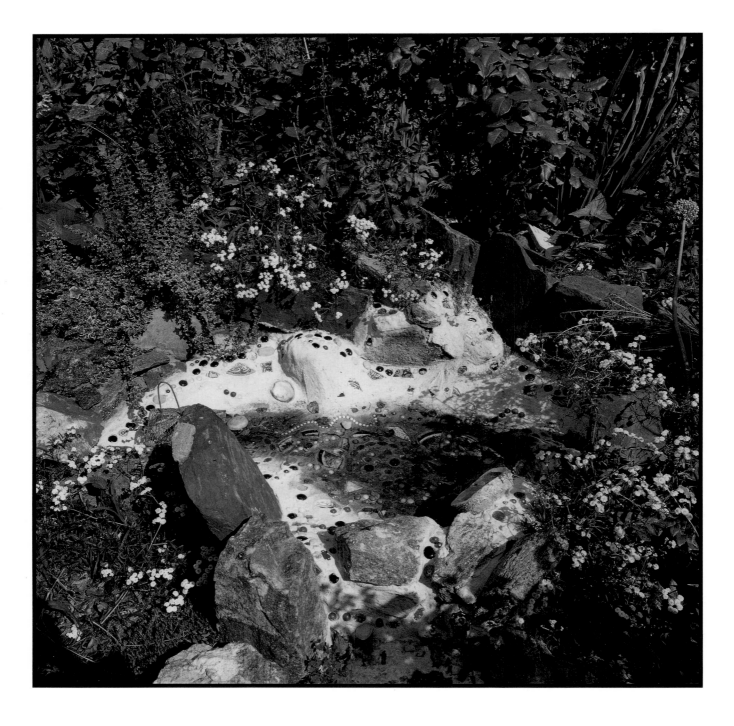

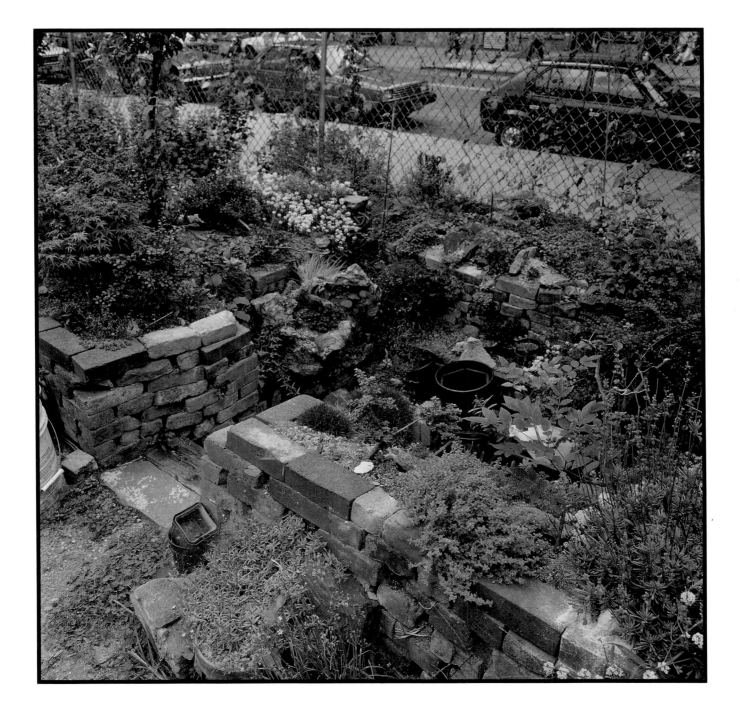

25 Ninth Street Garden

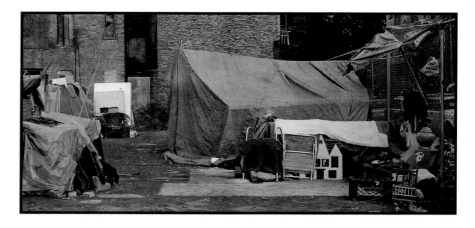

Eighth Street Garden

As community gardens become the work of public agencies, they may take on other functions as well. According to a former homeless resident, such is the story of the community garden on Eighth Street. When Tompkins Square Park was cleared of homeless people by the police on June 3, 1991, many of its residents moved to empty lots on Eighth and Ninth streets, half a block (Eighth) and one and a half blocks (Ninth) away. One of the evictees, Pixie, is unable to care for her two children because of her homelessness; the children are being raised by their grandmother and kept unaware of their mother's circumstances. On the Eighth Street lot, Pixie arranged a garden for herself next to the fence and around a green carpet with a sun umbrella, chairs, and a flower vase. She placed her small, crawl-in tent, fronted by a dollhouse with gables, behind her sitting garden. A doll sits on Pixie's lap, and a doll's bed is on the ground beside her. This lot, which Pixie shared with many of the homeless evicted from Tompkins Square Park, was a sociable place, where community potluck suppers frequently took place.

On October 15, 1991, a fire was set on the Eighth Street lot. Fire trucks came to put out the fire in the early hours of the morning; they were followed immediately by the police, who put up barricades on the street and watched as bulldozers plowed through the lot, destroying the dwellings and tearing down the fence. Between 5:00 and 6:00 a.m., the lot was emptied of all the homeless, who fled with whatever possessions they could carry. The lot was stripped of everything that had been on it. Immediately after the fire, a new chainlink fence was put up around the site.

The following spring, in this same location, the community garden at Eighth Street was started. Telltale signs of the lot's previous occupants are the planting bed boxes made of police barricades. The city's Operation GreenThumb put up a sign declaring this an

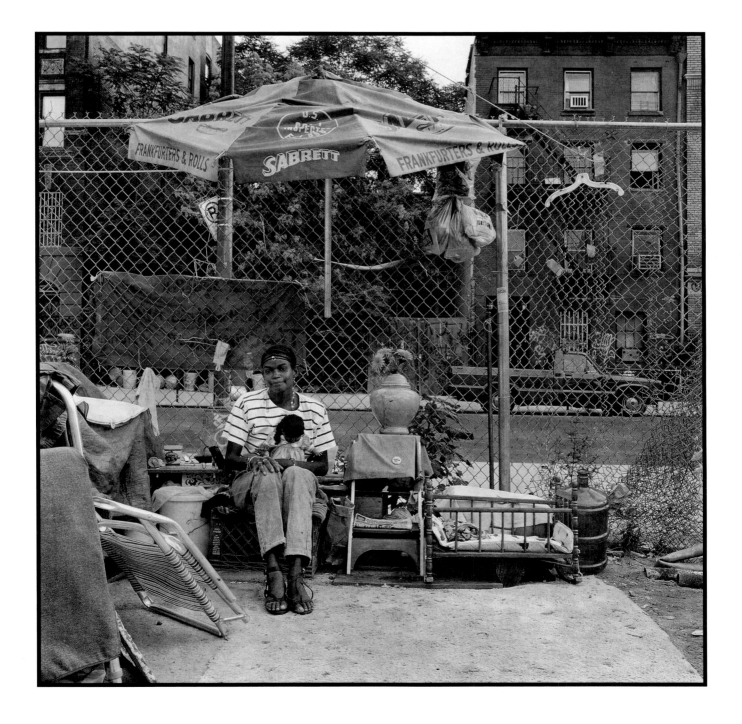

27 Eighth Street Garden

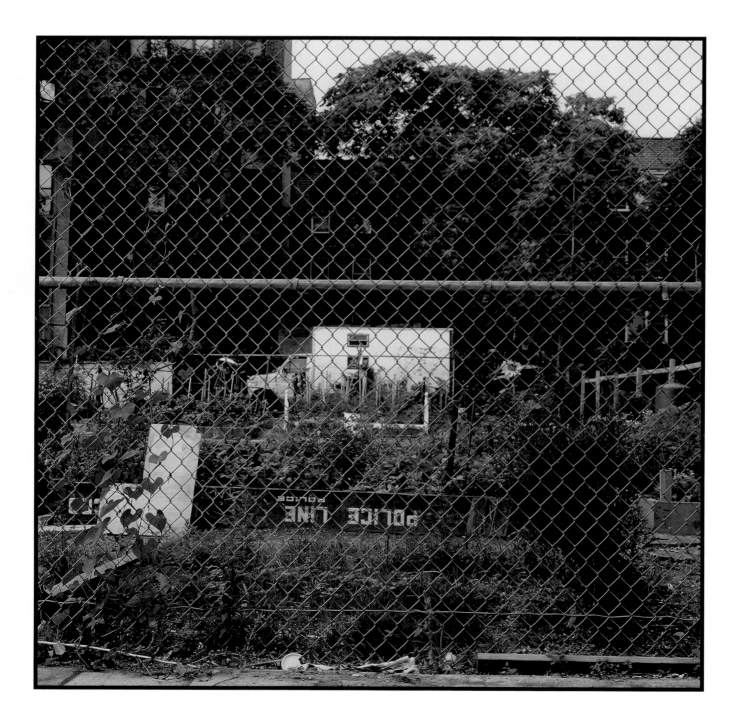

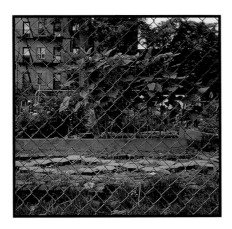

officially designated community garden. The garden prospered, and by the fall of 1992 it had become a redolent site full of fruits, vegetables, and flowers. Park benches were brought in, and its chainlink fence was covered with morning glories.

There were complaints from homeless people, including Pixie, who had been thrown off the lot. The city, they said, cared more for plants than for people.

Appropriated Gardens

Tenement dwellers, as individuals or groups, sometimes take over land to make gardens. Since the tenement dwellers have a legal place of residence, however, their efforts have more continuity and are longer lived than those of other transitory garden makers. In some cases their garden making becomes the basis for the establishment of an official community garden, and it is possible to see certain of the squatters' and tenement dwellers' appropriating efforts as the first stages of community gardening. Yet, as the squatter Pitts has stated, there is among these two groups a great distrust of government agencies, bureaucracies, and rules, and in many cases the garden makers specifically want to avoid such interventions, preferring to make their own way in spite of the danger of having their unsanctioned gardens destroyed. These garden makers believe that as long as the city lots remain vacant, the holding of the land by garden use is an improvement over holding it by ownership. We call these gardens, of which two examples follow, appropriated.

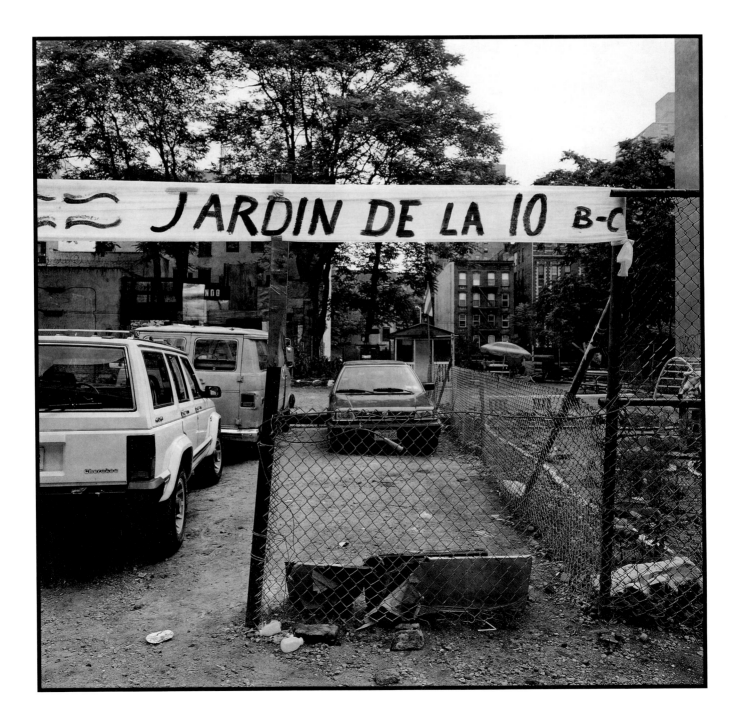

31 *Jardín de la 10 B - C*

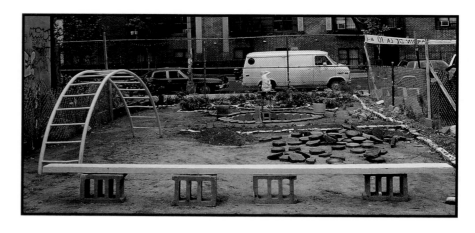

Jardín de la 10 B - C

Formerly a parking lot with a chainlink fence, an empty plot of land on Tenth Street between Avenues B and C over a period of months metamorphosed into a garden. The first sign of change was a banner in Spanish heralding the arrival of *Jardín de la 10 B - C*. Weeks later a piece of playground equipment appeared on the site. The next additions were benches made of concrete blocks with a wooden board spanning them. Planting beds were created and outlined with bricks, which were painted to emphasize the borders. Finally, the garden's centerpiece was built: a fountain topped with a concrete sculpture set on two upended concrete blocks, its basin dug out and lined with hexagonal paving blocks.

We can trace these pavers to another site of habitation for the homeless: Tompkins Square Park. Hexagonal pavers were pulled up from the pavement during the upgrading of the park that had followed the riots associated with the eviction of the homeless from the park in the spring of 1991. The pavers sat in neat piles on the sidewalk outside of Tompkins Square Park, but only for a few days; there was no need to dispose of them because they were recycled immediately. Some of them found a home in Jardín de la 10 B - C, which was created at the same time that Tompkins Square Park was being rehabilitated. It is possible that an inhabitant of the park with a watchful eye found a new use for these remnants of his or her old abode.

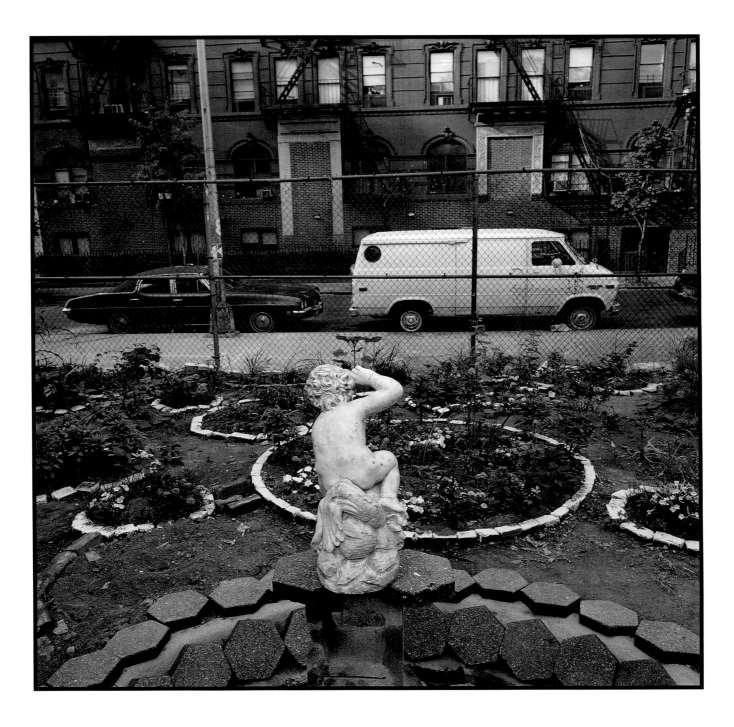

33 *Jardín de la 10 B - C*

Anna's Garden

The only way to get into Anna's garden, which is surrounded by a tall chainlink fence, is to remove the warning sign and squeeze through the space between the last fencepost and the wooden post of the adjacent house. The visitor must be careful to duck under the wire that binds the fencepost to the house post about three feet above the pavement. There is a dog, a stuffed animal, right by the entrance. But there is also a real dog on the site, a dog about which the neighbors caution. A friend of the gardener lives in a dwelling at the back of the lot, which contains a forest of ailanthus. Arranged around the fence and hanging from branches or set in furniture dispersed throughout the forest is a menagerie of animals and dolls. The forest seems populated by small beings.

The sign at the garden entrance presages the sense of menace that hangs over the entire space, a menace that is generally unspoken. In the summer, the foliage and the play of sun and shade beneath the trees may bring momentary flashes of Edenic images. But in the winter, when the foliage is lost and the animals and dolls are revealed in the stark winter light, the garden has frightening over-tones. It only then becomes evident that, although the animals are intact, most of the dolls are damaged or maimed. There are here a menagerie and a coterie; the two groups are treated differently. The dolls, which may lack an arm or have a severed head or broken feet, are surrounded by intact animals. While the forest of ailanthus knits together the other odd elements suspended in it — a flower painting, a gravestone embraced by a skeleton against the chainlink fence, an evergreen wreath attached to the fence, orange plastic Halloween pumpkins hanging from the trees — the sense of tension between the dolls and the stuffed animals remains.

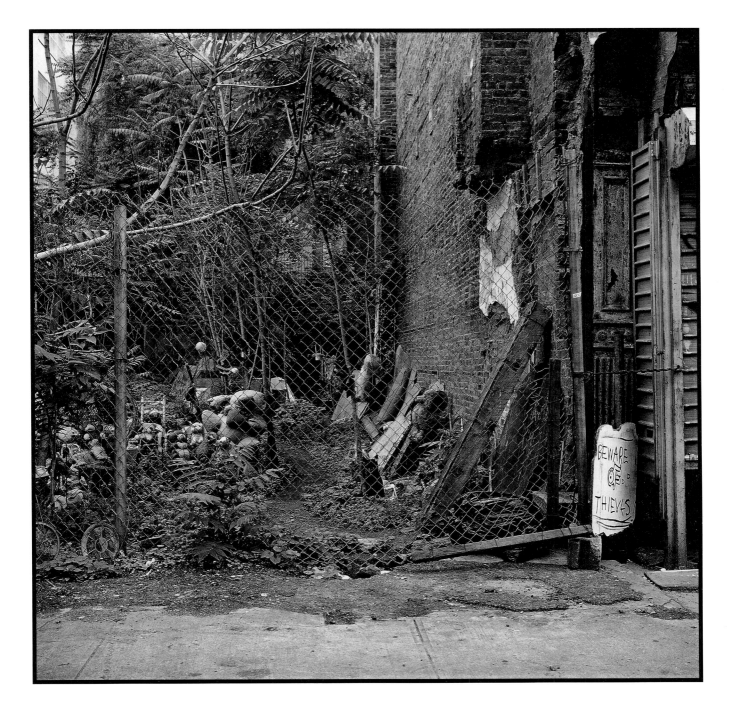

35 *Anna's Garden*

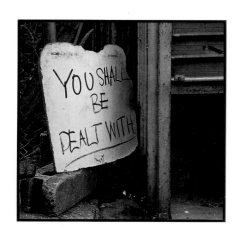

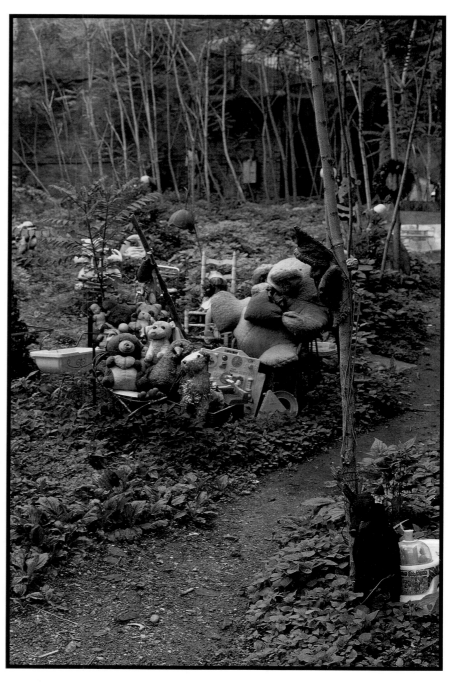

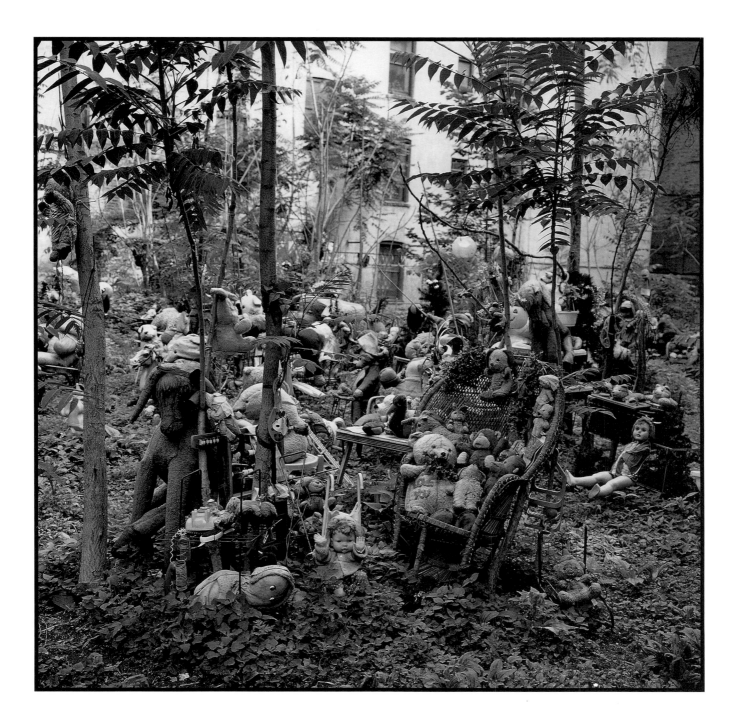

37 Anna's Garden

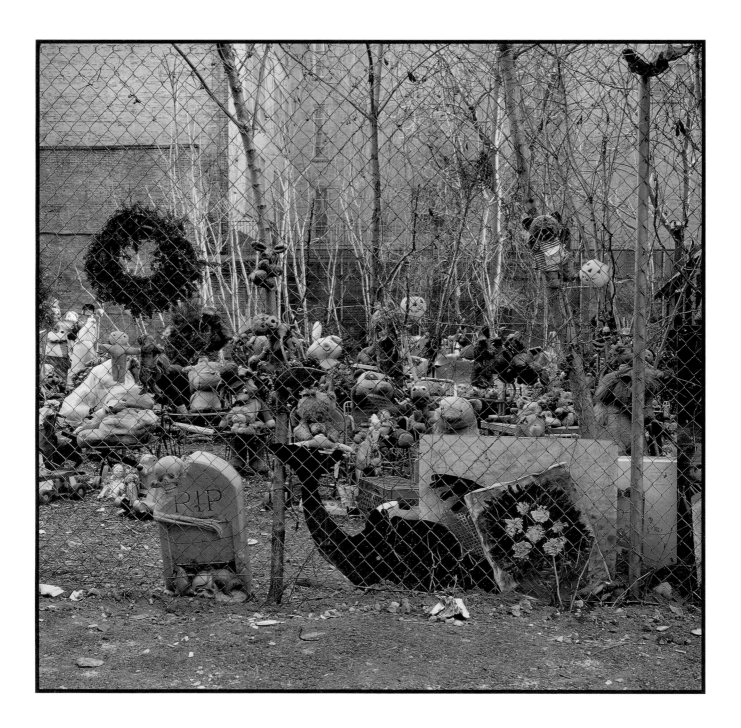

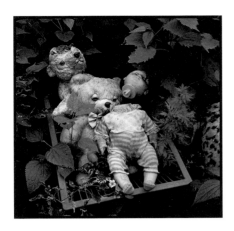

Small stuffed bears are piled up on seats or bound to trees and the backs of chairs; the enormous unicorn leans against a tree; the elephants, dogs, monkeys, rabbits look out upon the street; and the painted sheet-metal whale swims in front of the whole composition. We have here two gardens juxtaposed: a Garden of Eden for animals and plants and a garden of evil for the doll-humans. Wholeness is set against the wounded, and a feeling of imminent danger is pervasive.

The gardener is a recluse and lives in a tenement across the street from the garden she tends. She speaks to no one. The neighbors say that she came from Eastern Europe and was in a concentration camp as a child.

Squatters' Gardens

At times squatters, individuals who have illegally broken into and camped out in abandoned city-owned buildings, have also illegally made gardens on an empty lot near their squat. Pitts, a member of a squat called Foetus, describes the squatters' procedure:

To break into a city-owned building, to survive there for thirty days, and to have witnesses [two or three squatters usually break in together]. The best thing is to have mail sent to you with a postmark [to establish residence].

The squatters must do research to find out if their building is city-owned, and if it is, they do all the required construction work.

The garden is a way to hold the land. If you have the community behind your garden, the city is more hesitant to move against you, versus the squat riff-raff — not tax paying and dangerous.

The garden which some squatters set up is not for all the people in the squat, but just for those who work it. As we will see, in appropriated and community gardens, there is a closer connection among the surrounding building, the dwellers, and the garden than in squatters' gardens. However, squatters' gardens do infrequently acquire legal status as community gardens.

The making of a garden near a squat is more an individual activity than a group effort, and the garden tends to be a collection of unconnected plots, scattered helter-skelter over the lot, each plot claimed and tended by a different person.

To get into a squat is quite difficult. Two squatters describe what entrance entails:

You don't get into these buildings without having certain affiliations. Without a couple of introductions here and there, you're never going to get anywhere. We had to go through sitting meetings and being initiated. And working and then maybe getting a space. We lived there for like two months without having a key . . . knocking at the door and yelling out . . . it's just this really weird political crap that you have to go through.

Serenity

Serenity is a squatters' group whose garden does not have legal status. Pitts says of this garden,

At Serenity, people first took over the squat, then took over the garden. They were not politically interrelated. A woman by the name of Emilia who lived in the squat is the head of the garden, and a man by the name of Steve also played an important role in it. But only those two, no one else in the house had anything to do with it [the garden]. Also a man by the name of Billy was important in the garden. Billy lives in Queens now, but he also has a house in back. You need the approval of these three to get a key.

According to Jimmy, another squatter, he and his uncle did most of the landscaping work at the garden. They created the pond and walkways, while Emilia did the plantings.

Jimmy says of this planting,

I don't know nothing about plants, but I'm learning. My art is the landscaping. I consider it my art.

Pitts describes the Serenity garden:

It is and it isn't a community garden. It doesn't have community garden status, but we don't necessarily want it because you got to go Operation GreenThumb, and then they tell you what to do. You've got to follow a bunch of rules about when it's open and who gets to use it. Just because you live in the building, you don't get the key. We've almost had to bust some heads a few times.

Pitts goes on to tell why he left this garden:

My ties to the Serenity Garden ended when Emilia and I broke up over politics, and I started my own garden. We were two conflicting personalities. She was the boss of the garden. I am aggressive by nature. That scares people. I came one day, and the lock was changed. Instead of becoming obnoxious, I decided to leave. Two personalities too strong to be in the same garden.

Foetus

Foetus, the squat to which Pitts later belonged, also has a garden:

The back of the building had been used as a dumping ground by the people in the squat. I felt it should be cleaned up if the house was ever going to be legalized. I saw an expanse of land going to waste, sitting there with all that dirt and rats. I saw a piece of land to maybe build a little house on for myself someday.

One of the only ways of holding onto the parts of the East Village that have not been gentrified is through gardens. It gives me a political base to fight from legally, within the system. It also covers everything within the political spectrum today for those of us who call ourselves revolutionaries. It covers recycling, artistic expression, and safe places for youth in the communities.

You can't beat the speculators. The speculators are inevitably going to win. The only way is to win politically. The Left has had a lot of time down here. We've lost Tompkins Square Park and a lot of squats, but the gardens remain. The only way to win the revolution is gardening and the acceptance by the Hispanics. At least it's a base to work from. When you hold land, it doesn't have the antisocial associations the squats do, where an antisocial element plays into the city.

Prior to its transformation into a garden, the lot adjoining Foetus had been occupied by a homeless community. The lot was cleared by the police on October 15, 1991, and closed with a padlocked, chainlink fence.

Pitts says,

I sawed off the padlock and put on my own. They have not put back theirs. That's support. Being left alone is a form of support. Sanitation has

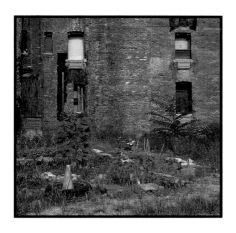

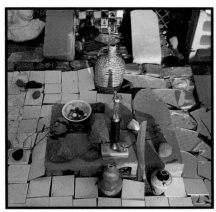

cooperated, given me bags, etc. I keep the area clean. I have a very good relationship with Sanitation. I would prefer that the garden doesn't get Operation GreenThumb status because of the rules the city imposes, such as no one can live on [the] property. Right now, if I choose, I can live on it or build on it. I want to have that option.

Five people are currently using the garden unofficially. Only myself at first. I am acknowledged as the person who has the status because I cleaned it up. I was bold enough to implement it. Everyone had an interest in the same thing, so we started cleaning it up. I assign the spots. If someone is interested, they track me down. I give them their spot. I watch how they work the spot, see how they are going to contribute. Then and only then, do I give them a key, but not at first. The other people using the garden are mainly Hispanics who expressed an interest to me.

I am acknowledged as landlord of the garden by the local Hispanics because I was the first to go in and clean up. People come by and get to know me. The chop shop mechanics ask if they can store car parts inside the garden. The chop shop is its own society. Only one of the mechanics has a key, Julio. Even though he is junior in the chop shop, I have given him control of the key.

I was already there [in my garden] before the van came and wanted to park cars they were working on. The advantage to me is that they are there twenty-four hours a day, my first line of watch. Watchdogs. I just woke up one day, and they were there. If I chose, I could be a rent-collecting landlord, but I take what they choose to give me. They keep me in rum and whisky. That's the payoff. For special favors on special occasions, they give me two or three dollars. For example, if friends of theirs want to store stuff in the lot. Maybe I've received up to fifty dollars in cash in the last year, but I have never asked them for money.

Tony came and asked me if he could move in there. I let Tony in to control the antisocial element. If you don't have the right people to hold onto your land or your squat, the drug dealers come in. These antisocial elements are always on the lookout to take over your land. All you have to do is let one of these guys in. Most of the fires are started by drug users, carelessness.

The first thing I consider is what's in it for me politically: 1. Tony's Hispanic. 2. He provides protection to the garden. 3. A number of Hispanic mothers in the community are concerned about children going out on the street. They will permit the kids to come and play in the garden so they won't fall prey to drug dealers. The Hispanic community is always watching. They all know each other.

This garden is a contribution from a number of other gardens around the neighborhood. So I didn't pay attention, in fact, to what I put in it. Now that I have studied, I know what's down there. There are pumpkins down there, there are collard greens, there [is] red cabbage, there is dill, there is mint, there is tomatoes, and a lot of sunflowers. There is also squash and corn. The people that have done the work are the ones who will be able to partake.

The pond was there, before I made it, in my mind. Next time you come, you will see my approach. I am very slow and methodical in my approach. Everything you see in the garden, everything you see out there, was gotten from the rubble pile. So you can change that over there into that if you are willing to work. I am very content within myself, provided I go down and work every day in my garden, and I don't really need too much more beyond that.

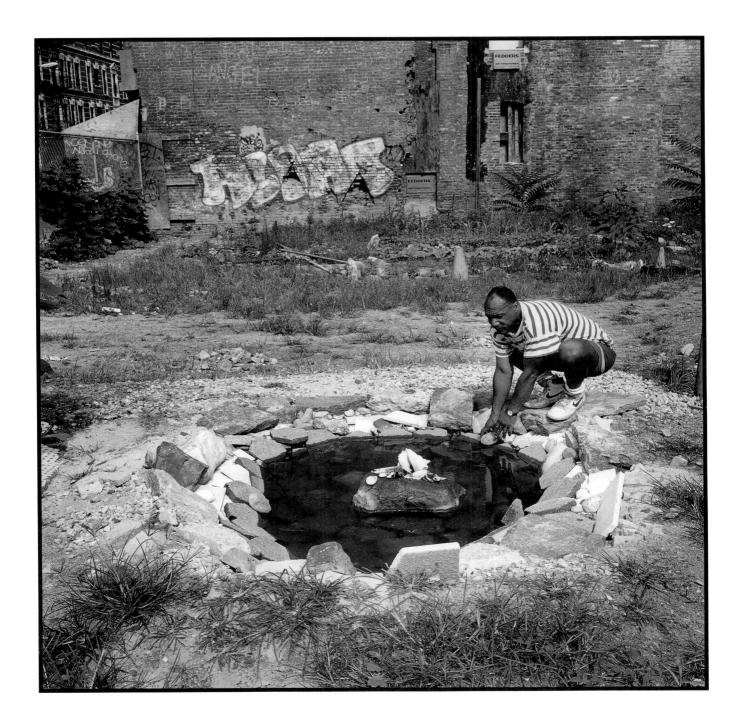

47 Foetus

Jimmy, who originally lived in the Serenity squat, came to the squat called Harmony. According to him, the community around the squat has not objected to the takeover of the land for the creation of a garden. Such a transformation is preferable to rat infestation of the lot or trash dumping or habitation by homeless people.

The garden is totally separate from the squat. You don't get a key just because you live in the squat. You don't get a key unless you are working part of the garden. Whoever contributes gets a key. You don't just store your shit in there.

Before the lot was cleared, it was buried beneath a six-foot-high mound of trash traversed by a walkway leading through two back-yards to the rear entrance of the squat. Because the street side of the squat was boarded up, the walkway was originally the only entrance to the building. In response to complaints from the neighbors over the rat infestation, the Department of Health cleared the trash out of the lot. Jimmy immediately put up a gate that he found along the street. According to him, the earth in the garden

is swamp dirt from the Lower East Side. From here to the East River it is all swamp, landfill, great dirt, black like coffee. It's the best dirt around. We get it when they are doing excavations, like lowering basements. You gotta clear the ground first, then cover it with about four inches of swamp dirt.

With Eddy, another inhabitant of the Harmony squat, Jimmy has done most of the work in the garden. The two men have planted a small spruce tree and two silver maples, built housings for the trees, and grown tomatoes and squash. They have placed statues in the garden and draped them with pearls, and they are in the process of digging a serpentine pond that they hope to line with garbage bags and fill in the summer. The pond will be stocked with carps.

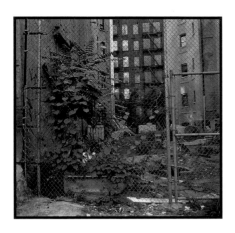

Squatters' gardens, appropriated gardens, and community gardens share certain characteristics. The hazy lines by which they are differentiated, the changing status and conditions of these gardens, may make these categories seem confusing. But the greater difficulty in categorization is in defining the enormous vitality, energy, and fluidness in current garden making in inner cities. These are the qualities that speak of its ephemeral nature.

Gardens of the Homeless

Still another category of gardening in the inner city is that of individuals who are homeless. A garden made by a person without a dwelling place seems nearly a contradiction in terms, but this kind of gardening activity is perhaps the most interesting of all that has appeared in New York's Lower East Side. Here we will observe several gardens that, while individual, have as a common characteristic the homelessness of their owners. They also share the kinds of building materials they use.

Garden Building Materials

Several materials are commonly found in these gardens — skids, milk crates and bread trays, shopping carts, carpet and matting, furniture, and, of course, water and containers for carrying it. Most of the building materials are found or recycled.

Skids are often used commercially to support or elevate a structure or to deliver heavy materials such as tiles or bricks. They are the most conspicuous and versatile of all the garden-building elements. Also known as pallets, skids are frequently used as staging surfaces for the unloading of merchandise from trucks and for keeping goods off a dirty or wet sidewalk. As such, they are of great use in these gardens, where they serve as mats, fences, dividers, walkways, front yards, tables, or inclined ramps. Skids are found in a few well-known locations in the city.

The plastic milk crate is second only to skids in importance as a building block. Alone or stacked, they make benches, tables, containers, planting beds. They can also be taken apart and made into a fence. Bread trays are made from the same plastic as the milk crates. Used to deliver bread from trucks to restaurants and stores, they serve a purpose similar to that of the milk crates. Because they are

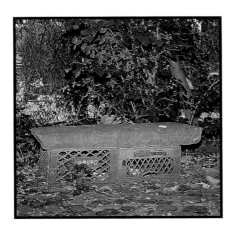

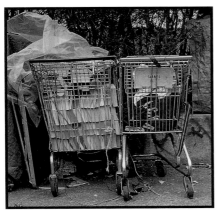

large and flat, they can be made more easily into a fence or even a portico, as we see in Pepe Otero's place.

For the homeless, shopping carts bear an affinity to the automobile, and like the automobile in the traditional yard, they are ever-present in these gardens. Dominating the usually tiny garden space, the shopping cart is the most visible element in the garden. The heavy chains and lock by which it is attached to a dwelling or to the sturdiest nearby structure — a wire fence or lamppost — are a clue to its valued status. Shopping carts are frequently filled with plastic bottles or metal containers or pails for carrying water. They are, like cars, a means of transportation, serving to carry whatever may have been found in the trash that is useful as a building material for a dwelling or garden.

Matting or discarded carpet is regularly used to create a front yard in these gardens. These yards are small but in scale with whatever dwelling is on the site. A ground covering sets off a space from a garbage-strewn lot; it provides a clear path and surface, above the dust, mud, or debris.

Furniture, especially chairs and benches rescued from the trash, are very important elements in the garden. For these gardens are places to be in, even if they are only as wide as a chair. Because the dwellings are small and used mainly for sleeping, activities such as eating, sitting, working on construction, and gardening all take place in the exterior space. The sitting element is especially critical, and furniture adds to the sense of the importance of the space. Milk crates, board benches, a wheelchair, lawn furniture with sun umbrella, a skid-made table with two chairs, all show accommodation for outside living.

Plants and Animals

The transitory and fragile nature of these gardens makes plants a luxury. Of all the things needed by human beings and plants, water is undoubtedly the most important, and it is not available on any of these sites. Here, we have urban living without the urban infrastructure, the essence of cityness. Life is more like that in a settlement. Fire hydrants are the only source of water, and the heavy, water-filled containers present a transportation problem for the homeless. The ubiquitous shopping cart becomes its main solution.

The absence of water in these lots may have something to do with the great interest taken by the residents in ponds, shallow depressions made in the ground and lined with black plastic garbage bags. These serve as reservoirs of the precious commodity.

Living plants are not the main feature of homeless gardens, primarily because of the scarcity of water and the difficulty in obtaining it; but also plant growth takes time, an element these planters, who may not stay on one lot long enough to see such growth, do not have. It is, in fact, surprising that under these extreme conditions any of the gardens have living plants at all. Plants, therefore, even a single plant, are featured as an important component. If there is no living plant, then a representation of one, often a pot with plastic plants, is usually substituted; artificial and dried plants are common. The few live plants that do appear in these gardens are not productive; by and large, these gardens do not produce food, and food production, therefore, is not the primary motivation for making a garden here.

Almost as common as artificial plants are animals, live or stuffed. Stuffed animals are second only to plants in importance, and sometimes they are more important. Live animals do appear in these

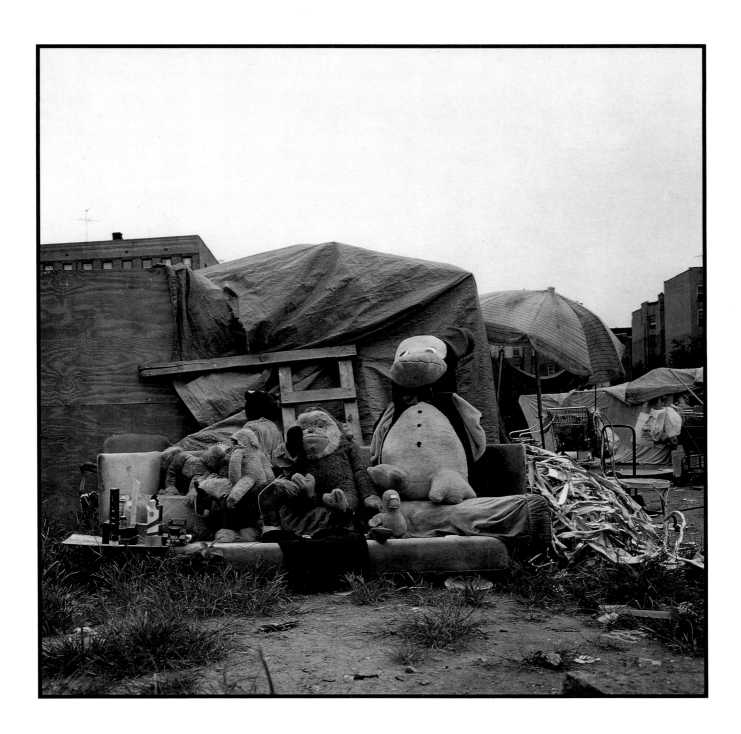

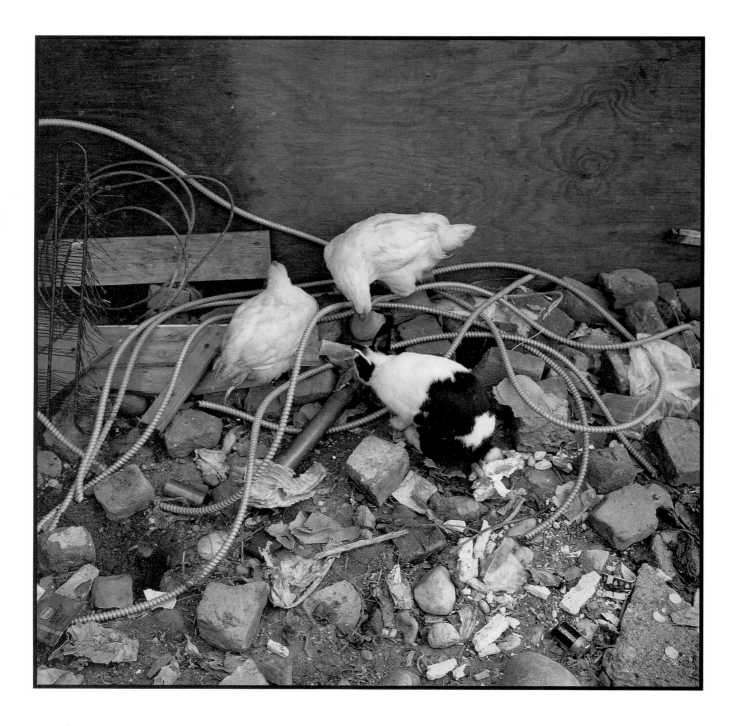

settings: chickens, rabbits, dogs, and cats most frequently; turkeys and geese occasionally; a praying mantis in one instance. These animals live as tenuous an existence as their owners. Sometimes they appear as pets, as in Louie's story, and sometimes they are called pets but are really a source of food, as in Juan's story. But stuffed animals are the genies of these gardens, serving sometimes as humorous figures, other times as guardians. They are always, however, elevated to an important status in the garden. Like plastic plants, stuffed animals don't require food or water, very scarce commodities. In these gardens, there are always references to plants and animals — in some form or other.

Garden Spaces

Gardens are mainly exterior spaces. The ones before us are most commonly three or four meters square, the size of a common rug. Such small areas usually play the role of front yards, including a sitting space and a composition of plants and objects, but they may also be shaped as courtyards, porticoes, porches, walkways, fences, or even burial sites.

Settlement in a trash-littered, abandoned lot creates the space or yard in which the garden will be made. Sweeping is the next step toward making the yard; sometimes it even precedes the building of the house. As building materials are extracted from the surrounding litter or trash and accumulated, the yard serves as a staging area for the construction of the dwelling and the garden. Sometimes the yard is made only by the sweeping, but more commonly it is created with discarded materials such as carpeting, matting, plywood, or even cardboard. These materials make a practical area of access. As the lot fills up with new arrivals, these mats define an extended, private, exterior space.

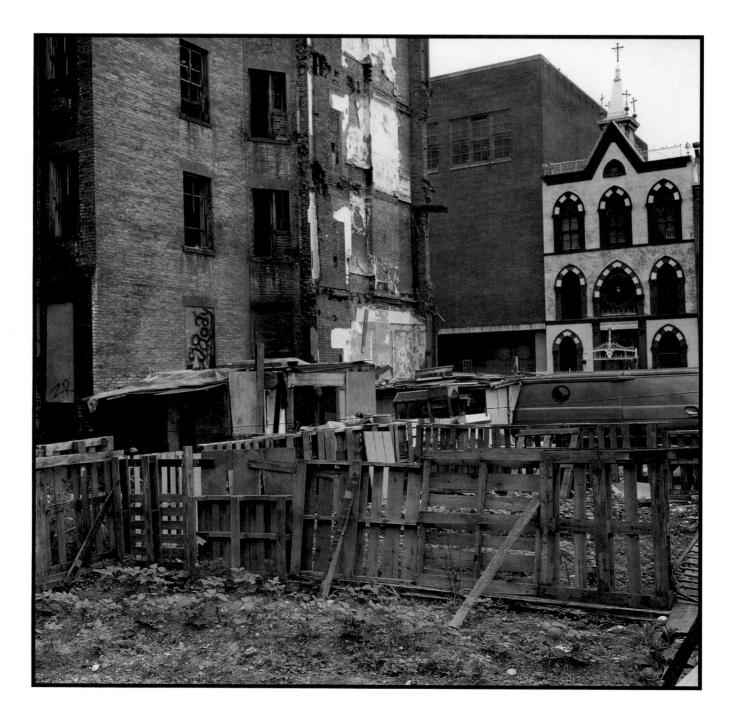

56 Gardens of the Homeless

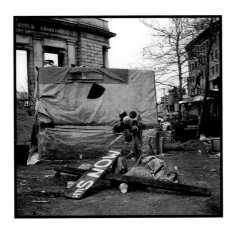

Courtyards, porticoes, and porches, tied into the juxtaposition of yard and dwelling, are also important spaces. Because they are walled but not roofed (courtyards) or roofed but not walled (porches and porticoes), these remain exterior, but defined, spaces. Courtyards appear much more frequently among the dwellings of Puerto Rican residents than among those of non-Hispanics. They serve as private spaces and as garden. They are also at times first steps toward enclosing a space and making it interior.

Fences play a critical role in all of these gardens. They vary in material and in function. Supplies for a dwelling are often scarce, and the effort and material that go into the garden fence at times equal, if not surpass, that which goes into the house. Of all the fencing materials, the most ubiquitous is the skid; pieces of several skids are usually arranged horizontally to make a fence pattern. In Bushville, fences are used for exclusion and for delineating the space that has been appropriated and made private.

Some of these spaces also hold markers for death. The deaths that take place on these sites, deaths of people and of animals, are usually marked. For the animals, there are actual burial sites. For people, there are markers. Again, the transitory character of the gardens and dwellings is also seen in these markers and places of burial. Here, a hand-lettered sign, casually placed, reinforces the prevailing impermanence.

Gardens of Homeless Individuals

The gardens that follow all belong to individuals. Situated on the Lower East Side, each one has its distinctive character. In most cases, the sequence of development of these spaces is structure first, garden second. But in some cases dwelling and garden are built at the same time, and in at least one case (Jimmy's), the construction of the separate fish pond garden preceded his settling on the site.

Jimmy's Garden

An assortment of stones and garbage bags, five tires, an upholstered armchair, a skid, a refrigerator shelf, some ailanthus and goldfish, a wooden fence, and metal post: these are hardly traditional ingredients for a garden, but Jimmy combined them to make exactly that.

A pond filled with water sits on Jimmy's plot, although there is no water supply there. A fire hydrant down the street is his source. Jimmy comes through a hole in the chainlink fence at the back of the garden when he carries water from the hydrant to the site.

For his pond, Jimmy digs a hole in the ground. In a corner of his fenced vegetable garden stand the few tools he uses for digging. Plastic garbage bags, securely held by rocks, line the hole; the rocks create a stony bank, such as that on a creek. The green garbage bags are not used as is but instead are carefully turned inside out so that their black side is upright on the bottom of the pond. This positioning lends more reflectivity to the surface and an illusion of depth greater than the pond's actual six inches. Six or seven orange goldfish are suspended, like golden sunspots, against the dark bottom. Toward the street side, a low wooden fence borders the front of the pond. The skid and the refrigerator shelf form two ramps up from the water's edge. At the top of the skid ramp, the skid engages with an upholstered, red velveteen chair. In it sits Jimmy, legs crossed, enjoying his garden.

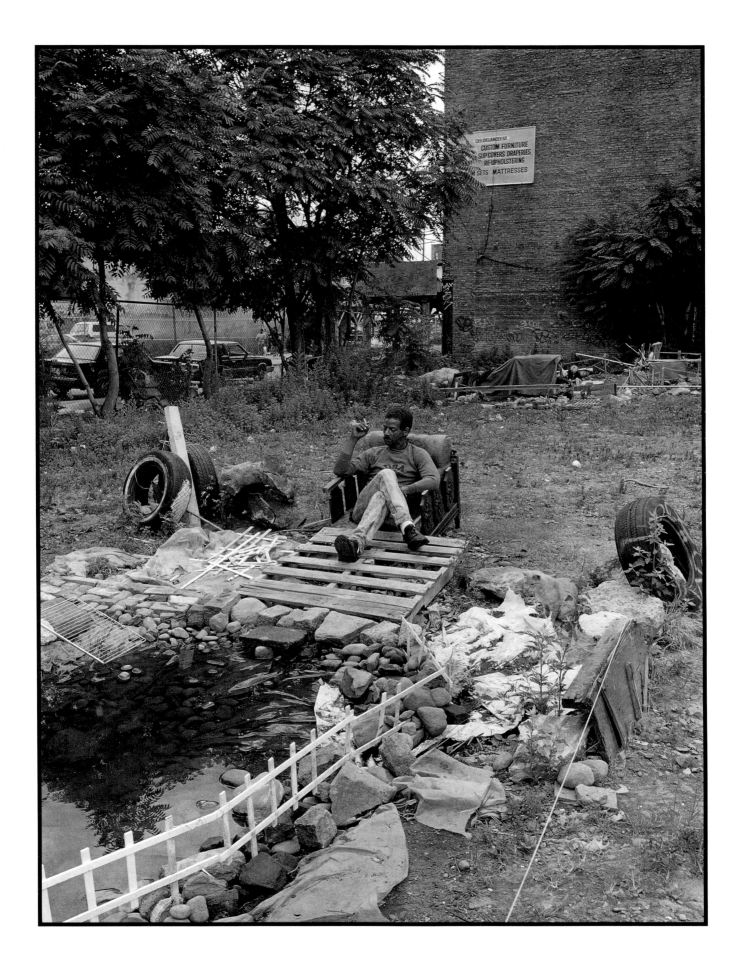

61 *Jimmy's Garden*

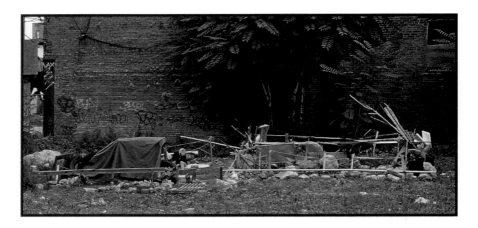

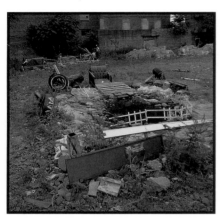

The power of this small pool of water to transform the site is remarkable. It introduces reflection, mirroring both the sky and the fronds of the ailanthus by the fence on the property line, highlighting the golden orange fish against the dark background of the plastic bags.

This is a carefully defined, edged, collected space in which fence, chair, skid, and stones combine in one composition. It is a "place," made by Jimmy for himself, a landscape in which his own pose of ease completes the picture. Ease, a sense of well-being, has been traditionally sought by garden makers, and it is what lies hidden in the Edenic image.

Not one of the components of Jimmy's garden is permanent. There are no underground pipes running into the pool; no concrete has been poured to make its basin. The pool, in fact, is but one example of the impermanence of nearly everything here, a site that overtly confronts the essential characteristic of landscape: the limits of time. At times, teenage boys come into the lot and steal the goldfish; other times, for cruel sport, they take them out of the water and leave them to die. Jimmy always finds a way to obtain money to replace the fish.

At the back of his garden, near the tent where he lives, Jimmy grows vegetables. Giving a tour, he shows off his tall corn and points to a hole he has begun to dig for a new fish pond in a safer, enclosed location. The hole is larger and deeper than that of the existing pool, and it has been lined with bricks. Jimmy says that he plans to work on it for the next several days. Clearly, the survival of his goldfish is important enough for him to recreate his pond completely. Jimmy's garden was bulldozed about eight days after this photo was taken, and he has disappeared from the area. But the moment in the garden that this picture captured remains — in this book and in him.

Nathaniel's Garden

Nathaniel is nicknamed The Mayor because he often served as representative of the hundred or so homeless residents of Tompkins Square Park. His space in the park makes one directly confront any preconception about what constitutes a garden. This one consists of a large mound of earth, leaves, sundry objects, and an area edged at the front by a metal strip, which sets a clear limit to the whole. There are found objects here, but they have been drawn into the overall arrangement. This array, built up with pots, plants, branches, and dead leaves, makes the whole site feel more settled. A sense exists of something composed, not just haphazardly piled, and this reduces the makeshift effect of the tent structure. It is clear that necessity did not drive the making of this garden.

I built the tent around a park bench. I had a garden outside. I've got a place, I've got a garden. It came from things growing, actually. Two or three big sunflowers came up there from seeds. I had a praying mantis there. I found it on the other side of the fence, caught him, and put him in a cage. I would bring him out to play in the garden in the daytime. At night I would put him on a stick and put him back in his cage. People would come by and ask to leave something in the garden: an earring, a flower. Some people wanted to add to it. Some would want to take away from it. Some of my friends would add something to the garden and come back and see if it was still there a week or two later.

The composition has a hierarchy. The concrete planter with shrubs in it is flanked by two figures and has a metal mat in front of it. The planter closes the composition as well as marks the entrance, while the arrangement of the garden replicates the mounding tent, though it is much smaller than the tent in height and width.

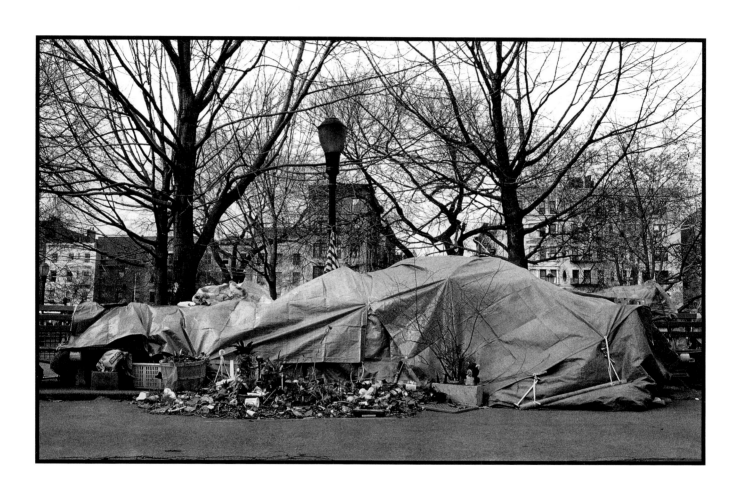

65 *Nathaniel's Garden*

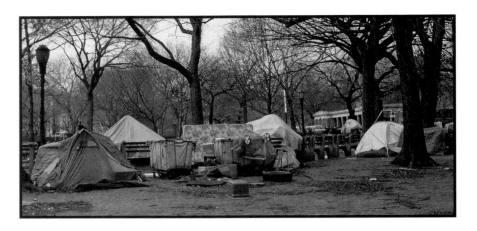

The Mayor acquired the earth for the mound in digging planting beds in three or four sections of Tompkins Square Park; he had been volunteering with the park upkeep. Seeds went into the mound, some plants grew on it, and the many objects were added as he described.

The Mayor's garden is a personal landscape in the purest form. There are no useful elements here: no productive vegetable garden, no place for sitting. It is a composition made for its own sake and for its owner's enjoyment, although it has a certain public face, since it is set out as a front garden. The front garden is the face to be shown to the world, and it is one that elicits a response. In this tiny space, we see the desire to interact with the world.

Before this photograph was taken, the Mayor carefully swept the area around the garden and the tent. Clearly, he cared about how his composition looked and wanted his work to appear in the best possible light. But the Mayor's sweeping was also undoubtedly motivated by the unstated hope that if his place were seen as being clean and in good order, he could stave off eviction.

At 5:30 a.m. on December 14, 1989, in fourteen-degree weather, the police expelled the residents of Tompkins Square Park. While the sanitation trucks ground up the remnants of their dwellings, the unprepared residents left the park with whatever they could carry. The Mayor soon moved back into the park, only to be evicted again on June 3, 1991. At that time, he was relocated to the Dry Docks on East Tenth Street and given a job with the city's Parks Department.

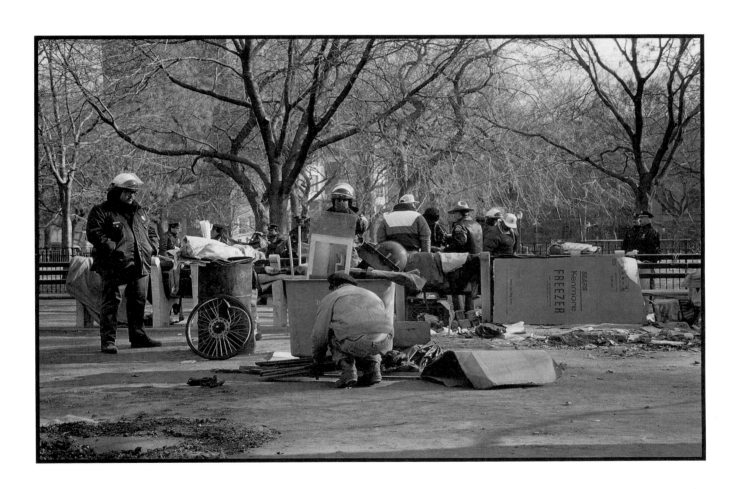

James' Garden

James' garden was on a city-owned vacant lot on Ninth Street between Avenues C and D. He made a dwelling there in 1988 but left for Tompkins Square Park when his tent was burned to the ground by an outsider. After the second eviction of park residents on June 3, 1991, James built another tent house on the original site and simultaneously began a new garden, using rocks that he found on the lot and bricks from a nearby construction site. He obtained paint from the trash of a nearby automobile body shop.

James expanded his house to accommodate three additional people, and at the same time he added to his garden a representation of a head on a pole and an arm with a rifle. During this expansion, the chairs overlooking the garden disappeared, and with their removal the garden lost its welcoming atmosphere. It took on the look of a place that would ward off strangers and protect those who were in the tent. The changes in the garden coincided with the increase in dwellings on the vacant lot from the original six to about twenty.

Many objects were added to the garden; small, playful pieces were found and placed carefully on each brick. Children from a nearby daycare center passed by daily on their way to East River Park, and James encouraged them to take a toy from his garden.

I'm a painter, and I got a garden, a nice little garden in the front, and we draw pictures, we paint pictures. But it keeps us busy, and we pick out all kinds of toys to put in the garden, to make the garden look good. We draw pictures from South Africa, and we draw pictures from all over, and we keep ourselves busy with drawing. It's all right and, like I say, we gotta make the garden look more better. If there's no rain we work on it every day. We ain't got no rocks to draw on right now. So when we get like a piece of nice rock, we do paint again. Right now our rock [supply] is low, and the paint's low, and we cannot do nothing now. Four of us work in

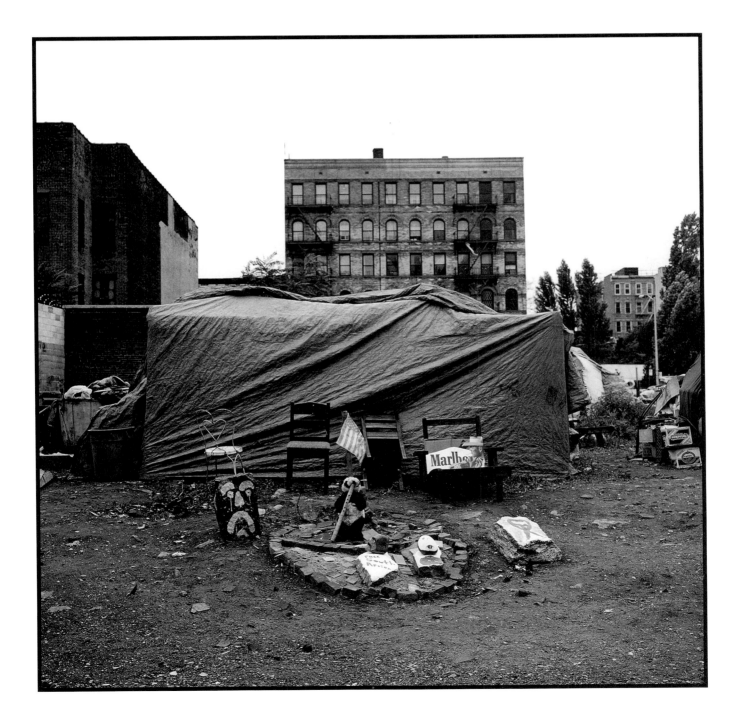

69 James' Garden

the garden, most of the time [just] me. I keep it clean. If we don't have it clean, they'll start complaining, and mostly everybody right now, they say, your garden look very clean and don't look like the rest of that yard over here. Still can't do nothing, it might rain on us. We want to change it around. It take time, oh, man.

The one [figure on the painted rock] you see, like crying, yeah, crying, and after, we put the painting like that. We make it shiny and that's the way it dry like that. That from black Africa, and the other man, he picking out the big rocks over his head, and the crying comes from black Africa, and the tears are coming down, and it looks like it real, too [laughs].

I don't pick any colors. If it don't look right, we take it off, and after that it come out so beautiful, and I say well, I'm going to keep it like that. See, and it gotta get dry, and when you get it dry, you put it up there and it's beautiful. We sand it to make the rock even, we sand it down, any kind of rock we see. I can make something out of that rock and the right kind of sandpaper. You can't get any kind of sandpaper, not . . . the right kind. . . . You use sandpaper, let it dry out for awhile, put the water on it. You wash the rock off, and we put a little paint on it. What are we going to put on there? . . . Look at it good, like I do all most of my time, like the garden, that my hobby.

We have the number one tent and the number one garden, and anybody tell you that, anybody, even those people in the school. Our tent, the cleanest tent in that lot, the whole lot, and we proud of that, you understand. We proud and that why every morning we clean and rake our yard up. Every time you walk by there you see it clean. We got proud. Every day I come by there — ain't junky, ain't dirty. It clean. Man, you understand, we are homeless, we are not helpless.

And we have all kinds of things in the garden, and the garden looks very nice, and we have like a lady head with a knife in it with a gun pointing

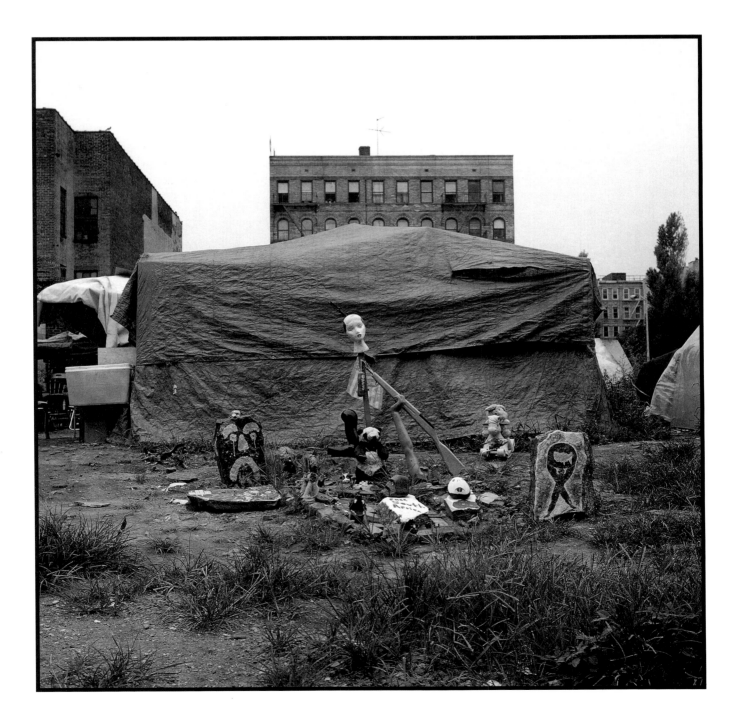

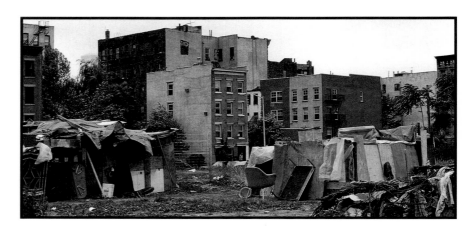

at her. That for a reason and because a lot of people know that means trouble. Even the cop know what it means. That for a meaning: away, away, folks. And we leave it outside at night time, nobody no touch it. And we got a black arm in the back. Like I said, we got a lot of things in the garden, a lot of art, a lot of drawing, and like I said, it beautiful.

[The painted rock was not stolen.] Know why? Because they can't pick it up. That rock is heavy. If they could pick it up, it would have been gone too. See, like there, they take the trophy [which a passerby, an elderly woman who admired his garden, had presented to James], and they don't bother with the gun. They don't bother with the lady head, neither. They not touch that. They can't put it nowhere else. If they put it somewhere else, we know where it at. See, the kids might be coming there . . . taking out this kind of car there, and after looking around, we find out we missing lot of things. We missing a lot. We missing the trophy. We're missing some cars, some animals.

Yeah, I came down from the South, South Carolina, Charleston, and my mother and my father, they taught me how to do that [to garden]. Oh God, I used to plant tomatoes, cucumbers, watermelon, all that, beautiful flowers, squash. I used to do all that. I was about eighteen when I came to New York. I came 1968.

I pick out bottles and cans, you understand, and I be cashing [them in] to buy food, and I don't harm nobody. I don't want nobody hurt me. Like I say, I'm homeless, I'm not helpless. People who come around, most like that garden. Most people, we don't let take pictures of that garden. We don't. Like yesterday, a dude came by yesterday. He was coming in and taking pictures of the lot. He don't understand. You're supposed to ask people when you want to do that. Happened yesterday. He like a big shot, and I tell him, hold it, hold it man. He say, he on the sidewalk. I don't care. You on the sidewalk, let somebody see you taking pictures on that lot,

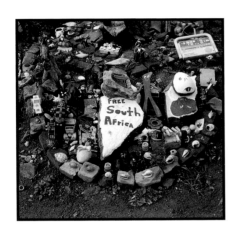

and see what happens. They tell you one time, and if you don't listen, they take your camera and they throw a brick at you.

You don't know where your pictures might go. You understand what I'm saying? We have people come in cars, sneak up on us. That's wrong. Ask! That's all you've gotta do. There ain't nothing wrong with "Excuse me, can I take a picture or something?" And I say, "What a nice way that he has, go ahead." You don't like people sneaking up. Like Sunday, they come in a car, taking pictures and going around the corner, and I saw them first time, and I say, don't do that, and they came back the second time. I pick up the rock, and I miss them. And the car was right there, taking pictures, and then just imagine, my sister and brother see that picture on TV or in the paper. That's wrong.

You can see into the back if you want to but come close. Right now you look in the back, you don't have nothing back there, you see. You don't. And like I say, I got to bring it out. And what I'm gonna do, I'm gonna add on see. Make a big difference next time you come by. It will be different, a whole lot different, see. And when you see you gonna be like oh Jimmy, how you do that — that when I gonna want you to take the picture. That when you take the picture, I tell you right now. That when I gonna let you take it.

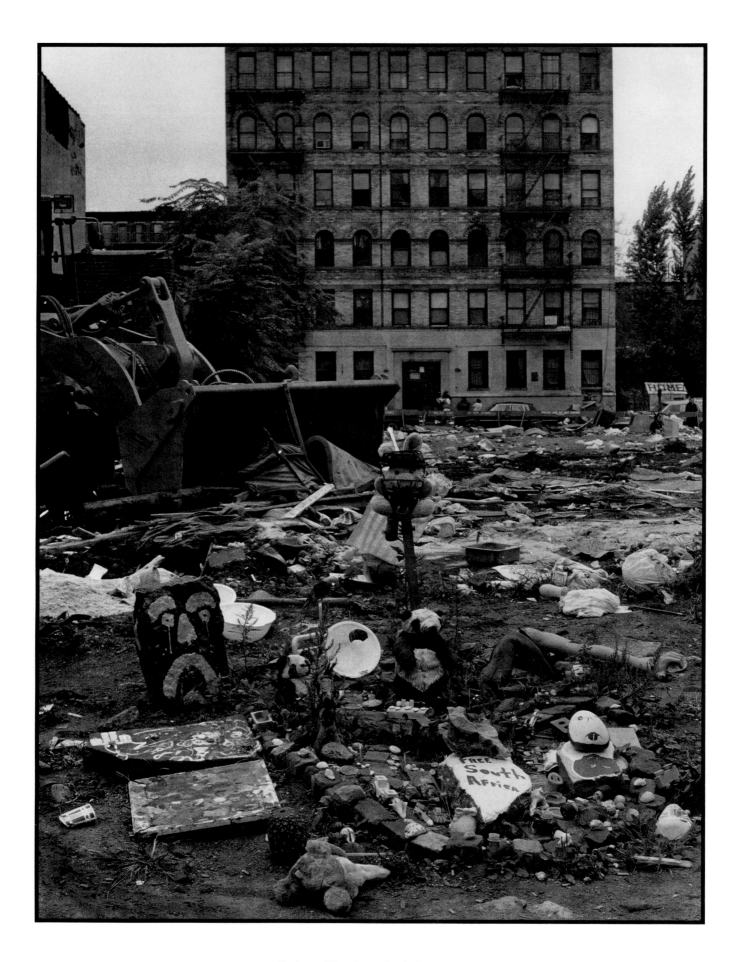

At five o'clock in the morning of October 15, 1991, a fire broke
out in a vacant lot on Eighth Street between Avenues B and C. The
lot had about fifty people on it. Several of the dwellings were de-
stroyed by the fire, and the residents fled with whatever they could
salvage. Most of them went to the Ninth Street lot where James
lived. The Eighth Street lot was bulldozed immediately by the San-
itation Department, sending even more of the residents to the
Ninth Street lot. The police followed and evicted everyone living
on the Ninth Street lot. The residents took what they could carry,
but the painted rocks that James had labored over were much
too heavy for him to transport.

*I had a beautiful garden. My garden was so beautiful. You got a choice.
Homeless is nothin' to play with. It gettin' cold now, and you got to see
how it feel. Like I say, I had a beautiful tent, I had a beautiful garden.*

Tony's Tree House

In a lot on the corner of Ninth Street and Avenue C stands a group of ailanthus, the trees that come up uninvited most often in the distressed soil of vacant urban lots. In this grove Tony has found shelter. The trees are Tony's anchor; they give structure to his place. Under and between two of them, he made the place for his plywood house and outside table bench. The tree trunks provide him with the equivalent of columns, and he has painted them up to the height of his dwelling, thereby integrating them into his composition. Tony's painting of the trunks adds a sense of cultural history to his site. In hot climates such as that of Puerto Rico, Tony's home, the trunks of citrus trees routinely are painted white to protect their delicate bark from sunburn. But here the technique is used aesthetically to transform the site, by drawing the trees into the constructed space. The canopy of the trees gives Tony shade in the summer, and the branches provide a feeling of shelter for the rest of the year.

Tony expanded his place by extending it linearly and frontally along the lines of the trees. The photographs reveal the place's development over time, its destruction, and its return, always under the trees.

While Tony was living on the lot, its population began to increase. As the population grew, so did the problems. In late summer 1991, while evicting drug abusers, the police cleared the entire west end of the lot, including Tony's place. When Tony returned in the summer of 1992, he began reconstructing his space, again anchored by the two trees; by the end of the summer, he had made use of four trees.

Tony came to New York from Las Piedras in Puerto Rico. He left there at nineteen, thirty-five years ago, because of lack of work. In the States, Tony worked as a cook and eventually became super-

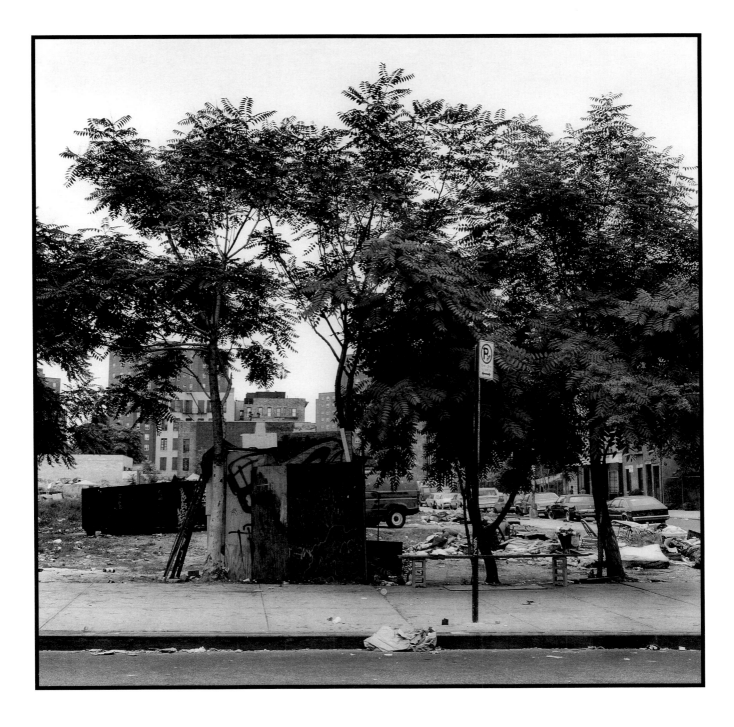

77 Tony's Tree House

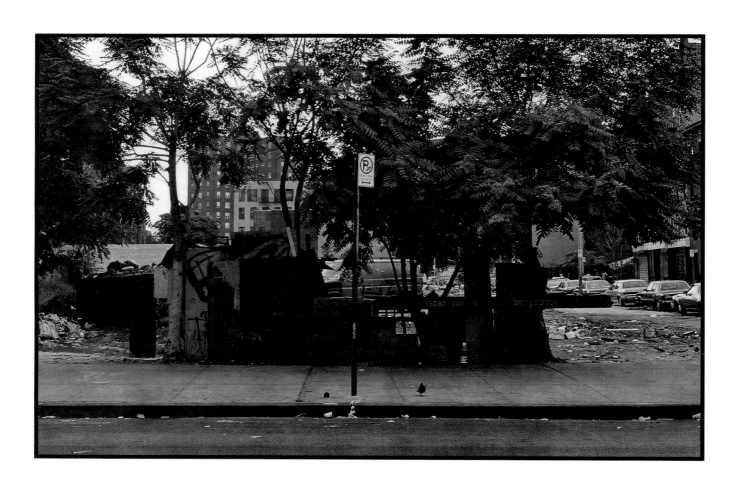

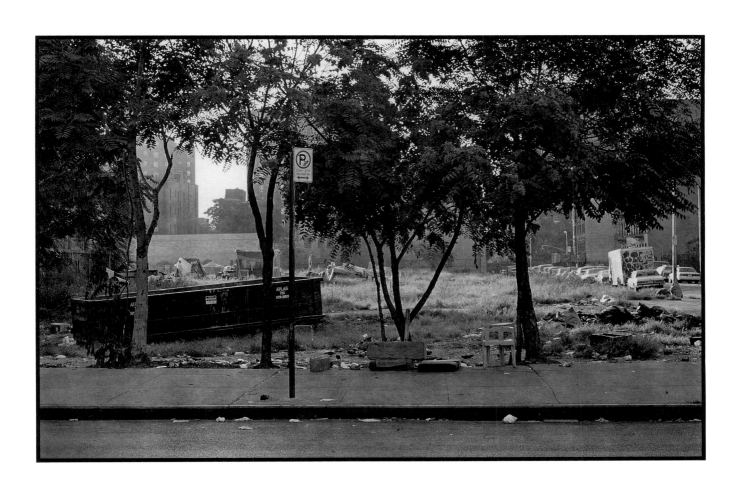

79 Tony's Tree House

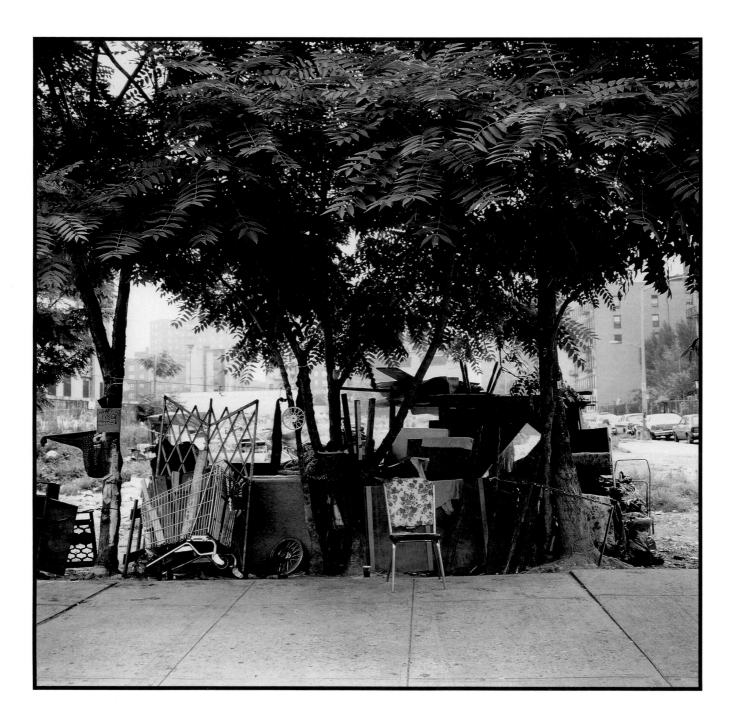

80 Gardens of Homeless Individuals

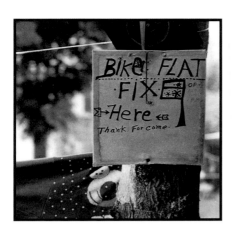

intendent of the building next door to the vacant lot on which he now lives. Tony has ties to the neighborhood; he is a part of its mainstream and is not tucked away, another unseen homeless person, at the back of the lot. A visible presence, he is a street vendor on a busy street filled with small shops and bodegas. From his sidewalk stall, Tony earns some money by repairing bicycles and selling the odds and ends he has collected from the trash or from people moving out of his old building. On the corner across from Tony's stall is a pastry shop, popular among neighborhood residents, and on weekends Tony's corner becomes a social place, a haven for street vendors.

I lived a long time in that building. My mother died in there, in that building. In that building they make wine in the basement, in the laundry room. I left it because they told me I had to leave almost two years ago . . . because the landlord now, he don't be able to pay. I know a lot of the people in the neighborhood a long time, old people. Now we've got a lot of new faces around here. If people are [on] drugs, you ain't nowhere. Go to jail, you know, back and forth. You go over to Riker's Island, you'll see a whole crowd of young kids, young boys with no brains at all. I've never been involved in that at all. All the old people, they know me from the neighborhood. [The people] that moved out of the building, they gave me a lot of stuff. That way I make a living. Sometimes I sell this stuff to buy my food. For now it's very good. People live better in the street than they live in [shelters]. There they live like animals. You don't live like a human being.

Tony moved to Pitts' lot. When Pitts moved away he offered his padlocked space to Tony.

Angelo's Garden

Two small toy gardens, as Angelo calls them, are carefully composed with granite pavers taken from part of this old pier on the Hudson River. One of the toy gardens is barely larger than a shoebox. The large one is fenced with chicken wire, through which a branch with a snake head is intertwined. Both gardens include flags, dolls, and stuffed animals. The flags are their main feature. The menagerie spills out of the garden into Angelo's backyard, where it settles on his table, and into the area behind his dwelling. A regulation size American flag stands right by his house. It doubles the height of the dwelling and crowns the gardens. He has placed small flags in the smaller garden on the top of the planter edging of the granite blocks. The fenced garden has flags at waist height.

The small dwelling acknowledges the view. Angelo has arranged his house so that he can look onto the water from his bed. This is a site with no edges.

Outside my house I have two gardens. It's not garden actually, no flowers or tomatoes or eggplants. It's a toy garden. I got a gorilla, Godzilla, a Barbie doll, and lotsa, lotsa toys. A lot of people come by over here. They just play with a bunch of knickknacks. They come over here and say, where did you get all this stuff? I say, I didn't buy them. The people that came over here they put them in there. It's like a museum. They come and say, "Do you still want the little toy, I give it to you?" And . . . nobody touches it. The garden, it's got a snake fence, snake take care of things, see I found that. And I found stones to make an edge for the garden.

Angelo tells how some of the toys got into his garden:

In the summertime I go swimming a lot. In the eleven years I've been living on the pier over here, I've saved eleven lives and lost two. Last year

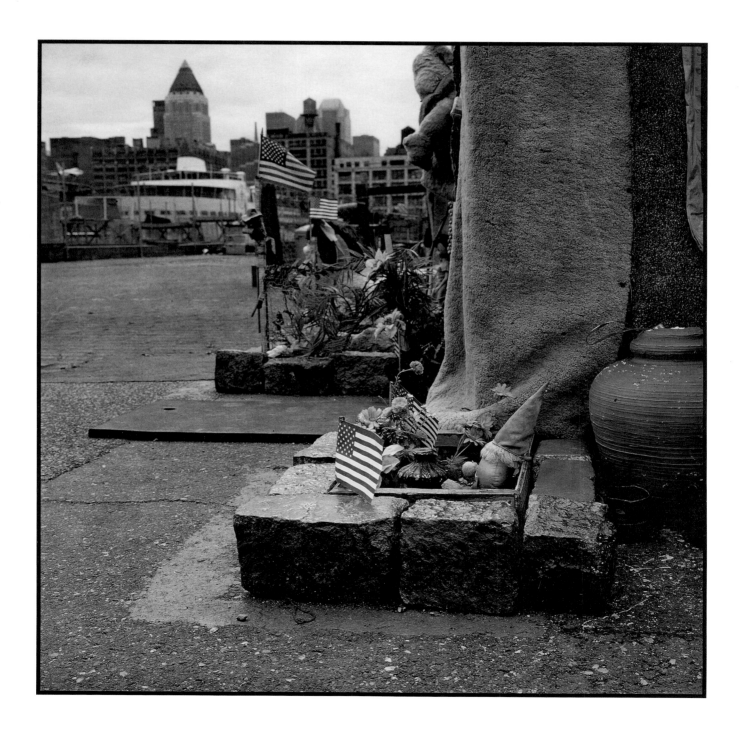

*they were fixing the pier over here, across the street from the hospital . . .
[someone] fell in the river. . . . I had to let him go. He tried to grab me, and
I kick, you know, because he tried to grab me, and if I did not let go, we'd
both be dead. A little Puerto Rican girl, seven years old, fell in three weeks
ago. It was February 29th, and I jump in the water and saved her. But
thank God, she spoke English. I said, "Honey, put your arm around my
neck, and don't let go." And then when she comes again she gives me a
name, she calls me Papi. I guess that means father or grandfather in Span-
ish. Her father, he's a junkie, they were doing drugs. They didn't care when
they came out here [with her]. They were screaming, and I said, "What
are you worried about now? I saved the girl." They didn't even stop to say
thank you. But the little girl last week, seven years old, she come over here
by herself . . . and she brought me a little Barbie doll. See, it's in the garden.*

*And in the last week of Christmastime, I bought a tiger. It's six foot long,
and a foot and a half high. I paid fifty dollar. Of course, they give me a deal,
because I told them what I was going to do with it. But it's a big, big one,
and so far nobody's stole it yet. The reason I came up to Pier 84 was when I
was on Social Security from 1983 to 1990 I was getting five hundred and
ten dollars a month, and I was paying one hundred and fifteen dollars a
week for a hotel in Coney Island. So that left me to eat five dollars a day.
By the time I paid my medicine and the hotel, I had nothing. I met a friend
who said, "Come down to Pier 84 in Manhattan." I'm from Naples. I
came when I was eighteen, work as a cook for a while. Worked in lots of
things, had my own restaurant, little place for a while. Then from age fifty-
five, nobody wants to give me a job. Who is going to hire me? I was mar-
ried, had three kids, sent them over to my mother in Italy. I call her and
say, here in America women can divorce you. They are in Italy in the U.S.
Navy. Rosanna, she's a Lieutenant M.D. Rosa, she's a helicopter pilot, and
Jeffrey . . . is going to be a dental doctor and is going to graduate this
September in Naples. . . . At Bryant Park Library I got my certificate from
Mayor Koch and Mayor Dinkins. It's not [that] I'm brave, I am just a*

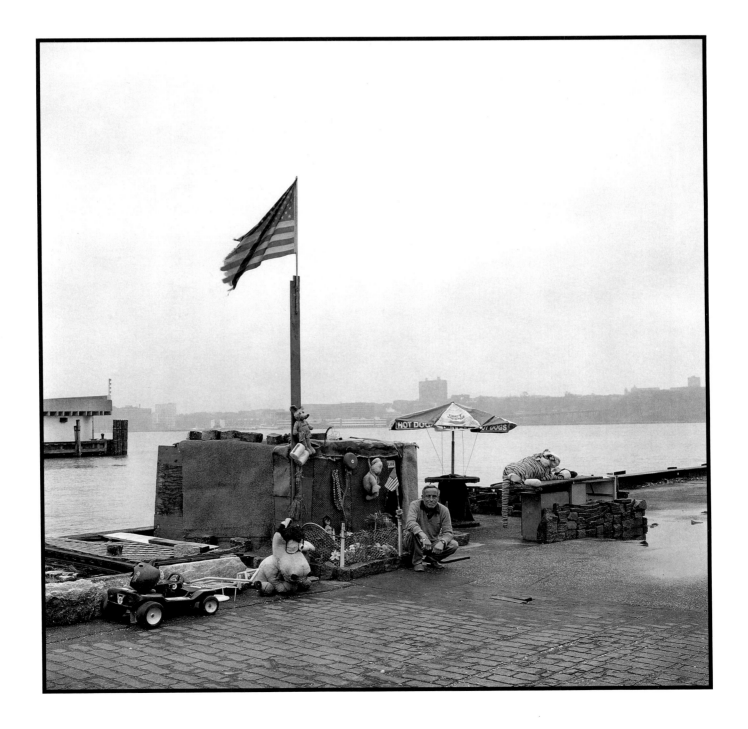

85 *Angelo's Garden*

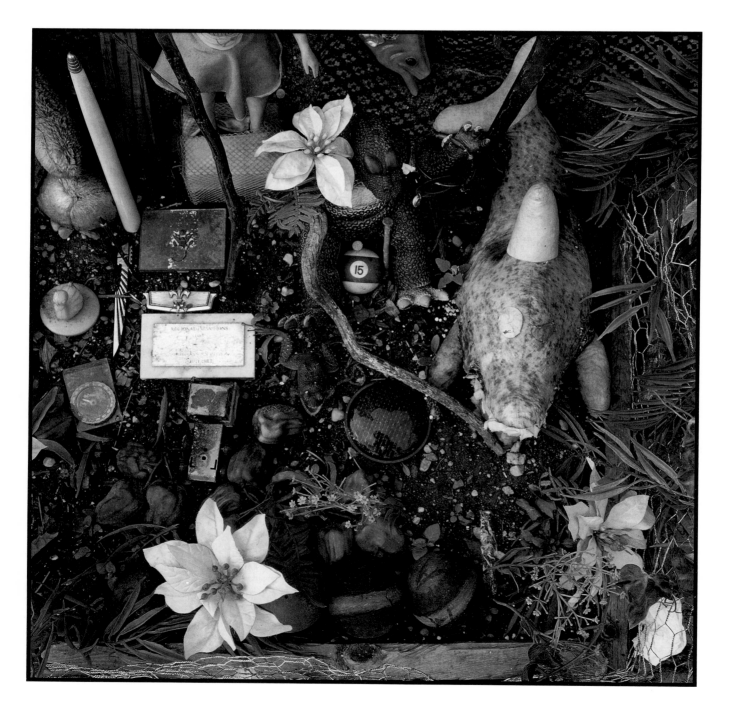

86 Gardens of Homeless Individuals

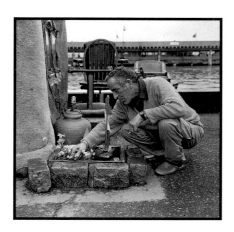

human being. I love people. They make me smile and I make them smile.
I'm an alcoholic.

Angelo repeatedly stated that he was an American citizen. Two
months later, the tattered flag standing in the background had been
replaced by a brand new one.

It's beautiful here, quiet. At night it's really beautiful. In the morning you
can see the helicopter from the news station flying over. You see, that is
WNEW. I'm putting in a big window to look out, got myself this one here,
put it in next week. You'll see it, next time you come.

Tim's Garden

Tim, a homeless man, built several gardens. The first was on a vacant lot, where he lived with several other homeless people, and it was destroyed. The second and third gardens were parts of squatters' gardens.

Although Tim's first garden was ruined, it survives in four different versions of the story of its destruction: one told by Tim himself and the others told by Rita, Donna, and a couple, Sam and Nancy, who also lived on the vacant lot. When the stories are finished, however, only one fact is certain: the loss of the garden.

At the time of Tim's first garden making, the vacant lot was becoming overcrowded with homeless people. As a result, there was great tension and hostility.

Rita describes the atmosphere: *They doing drugs, they see you with the camera, and they go around the corner and get twenty dollars for it. And the camera, I bet it's really worth a couple hundred dollars. You see, people don't think. Now they got their drug, their cocaine. You got people there that need money, fast money.*

When she was asked what happened the night before the disaster, Rita tells what she knows about the garden.

Rita's story:

All I know is that it went on all night. People couldn't sleep. A lot of arguing. I got [to] sleep that night, but I heard voices in the background, a lot of arguing. All about nothin'. It don't make no sense.

About Tim. One of the cats died. The people that live next to him — his neighbors — they said he put poison in his garden, and the cats had ate whatever that was and one of the cats died. Kathy and — I can't think of the old man's name — they had kittens, so when the kitten died, they [the neighbors] tore up his [Tim's] garden, and that was his pride and joy, and he left the next day. The neighbors were saying he was putting white stuff in his garden. That was rat poison, but it wasn't meant for the cat. He just left because of them tearing up the garden 'cause that was his pride and joy. Yeah, that's why he left. It's not getting any better since I first got here. It's getting worse, not better. That's why he left, can't blame him. That garden was his pride and joy. I don't know who did it. But I know it was done last week. Yeah, he put out his tent. Well, the house on the corner, they moved it and put it dead center. I can't think — whatever his name is — that's his house. He [Tim] left because Kathy's cat died.

Rita maintained that Tim left the vacant lot immediately after his garden was destroyed but that he stayed in the neighborhood, finding himself another place to live. When asked what happened to the garden, Rita said only, *It got terrorized.* She didn't know by whom. But she did know the reason: *Tim put poison in the soil, and one of the kittens ate the poison and died. That's why it died. That's what I heard. It was a kitten; it wasn't a cat, it was a kitten.*

There had been a sign on the fence of the garden warning of the presence of rat poison, and Rita was asked who had put it up. She said that she thought that *the people that are finishing that brand new building, I think they are doing it. . . . I think this man who lives in the building did it, 'cause that's where the rats coming from. They coming right out of that building.*

Whereas Rita blames the builders on the nearby construction site for poisoning the cat, thus triggering the destruction of Tim's garden, Donna portrays Tim more as a victim of his assertive personality and the negative attitudes and behavior of others.

Donna's story:

Well, for some folks, crack makes them paranoid. Like I was out there talking to the police about sanitation and pest control, and they got upset because I was talking to the police about bringing someone in to help us. And they don't understand why I was talking to the guy. I wanted him to bring in the pest control so we can control these rats. And they say, "Oh, this bitch is trying to be popular, and she's rattin' on us." They were so paranoid that they didn't understand that I was trying to help them. I was the first that got them rakes, brooms, dustpans, and brought in that man, you know, "Clean Up New York." I went and got him so they could get these supplies, but he didn't come back anymore because he knew that they were playing a game. So I'm never, never gonna stretch out again. Never. Tim got thrown out because Tim had a really flamboyant personality, and Tim was assertive, and Tim was also aggressive, and they didn't want anybody that is assertive. They's scared. There's envy and jealousy in that. That's why they put Tim out. 'Cause Tim was trying to show them what to do.

Tim blames no one specifically, although he points to negative attitudes and drug use by those around him as the base of his troubles.

Tim's story:

I got a year and some months here. I moved in during the summer. I lived in Tompkins Square Park until they came in, and then I lived in the [vacant] lot. And I left the lot because of the people that came into a spot I opened up. That was my lot. There was no one there before me. . . . Then, after I showed them the way to survive, and they don't want to do that, . . . they want to do it their way, which was drugs and all that . . . so I didn't want to walk with that. Then they attacked me by tearing up my garden and my area, because they don't like beauty. . . .

They destroyed my garden. I called them all together, and I told them to look up to the sky. Because by the time the sun was up on the top at twelve o'clock I'd be out with my tent and everything, and I'd move over here. And I told them they would not have over one month in there. . . . Exactly to the day, one month. . . . After living with these people for a year, seven days a week for twenty-four hours a day, 365 days a year, there is a clear division amongst the homeless — those who will and those who will not. The givers and the takers. The positive attitude and the negative attitude. These negative attitudes come from an abuse. . . . These guys are losers. . . . This is the exact same element that has not only destroyed my garden but physically assaulted anything or anybody on that lot . . . smoking crack all day long, twenty-four hours a day, perpetuating their negativity to the community as a way of life. I mean . . . people are tired and disgusted. They're not going to put up with this crap. I am not going to put up with it. . . . Now I came out here with a positive attitude toward the homeless — I am homeless myself. But, you know, there's a limit as to how far we let this problem get out of hand. After picking a spot I showed them. Every time . . . it was the same crap. "Who do you think you are? Who told you you could speak for the homeless . . . If I have a beef with you, I can take your house apart."

The story of Sam and Nancy:

They had a cat that would run around in his garden from time to time, a nice little kitty. . . . And we also had a cat that we would bring over and these two, they would run around together. And the kittens would play in Tim's garden, which he really didn't mind, he liked cats. And a week before the kitten died, Jud and Kathy's kitten died, we noticed that it looked really sick, just did not look healthy, and we mentioned it to them and they basically ignored it. And since they ignored it, I wouldn't let our kitten play, because I had no idea what this cat had and I told them they should take it to the vet. The cat was throwing up and just looked sick. It was lackadaisical, it didn't want to come out, it was laying under the bed all the time. Apparently what happened was the cat got out, they couldn't find it all day, and Tim found the kitten and it was dead. They say Andy found the cat in his [Tim's] garden. He says he found the cat in the lot. . . . They'd decided that the kitten had eaten something in his garden and that was what had killed him, and they went in, while he was gone, and they tore the garden apart. . . . What really shocked me about it was that all these people had been living there for all this time, and they all knew one another, and they just sat there and watched while they tore up this guy's garden. Tim can really be a pain in the ass, and I know at the time he was not getting along with a lot of the people there, however, I thought that the garden was the only bright spot in that place. That place was dismal. I hated going there, and I know a lot of people who really hated being there, but you know, the garden, it was something beautiful, growing out of what was nothing but despair. And they just sat there and they watched these people tear it up, and you know these are people who really

didn't want anyone else to have anything, you know, that's the way I saw it . . . and from that time on, I wouldn't go there . . . that incident changed my whole attitude towards them. . . . The amazing thing was that he didn't do anything, because he figured "I got someplace else to put my garden."

All four of these stories do converge on the existence of drugs on the site, but the supposed reason for the destruction, the poisoning of the kitten, plays a different role in each story. In fact, Tim does not mention it at all. What is common to all versions is that the destruction of the garden was very important: Rita believed that by the destruction of his garden, not his dwelling, Tim could be hurt the most — *that was his pride and joy*, she says three times.

Gardens of Homeless Communities

Bushville

On the Lower East Side there is an area known to its residents and its tenement neighbors as Bushville. Bushville encompasses a large vacant lot, and it recalls the Hoovervilles of the 1930s. Its name was taken from a sign found on the ground by one of its residents, Guineo, whose given name is Hector. Guineo has lived here for two years; his is one of the longer residencies on the site, which has been settled for about four years. Currently the lot has about twelve residents, all of whom have come from Puerto Rico. Guineo picked up the sign saying Bushville, repainted it, and nailed it to the front of his fence. Guineo collects signs and says that respect for the lot has grown since he put up his.

Because of Guineo's seniority, Bushville has evolved along the organization of his space making. Those residents who have come in after him have lined up their structures with his, then put in some sort of front walk. Some have planted a garden by their dwelling. Others, however, have planted large patches totally separate from them: carefully dug, fenced spaces containing beans or tomatoes.

A wide path, something akin to a main street, traverses the lot. It is formed by the fenced gardens that are set to one side and the houses to the other. Because the lot is in the middle of a long block, it provides a useful shortcut: from the nearby projects, neighbors — most of them are Puerto Rican and speak to the residents in Spanish as they go by — cut across the lot, using the main walk. Each house along this street has a distinctly separate, semiprivate porch or front space that fronts on the main walk.

To a passerby from the street, the south entrance to the lot is a garbage heap. Sometimes the trash mounds up on both sides of the path, making a gateway to the village. It does not consist of the trash of the Bushville residents, however. The mountain is the

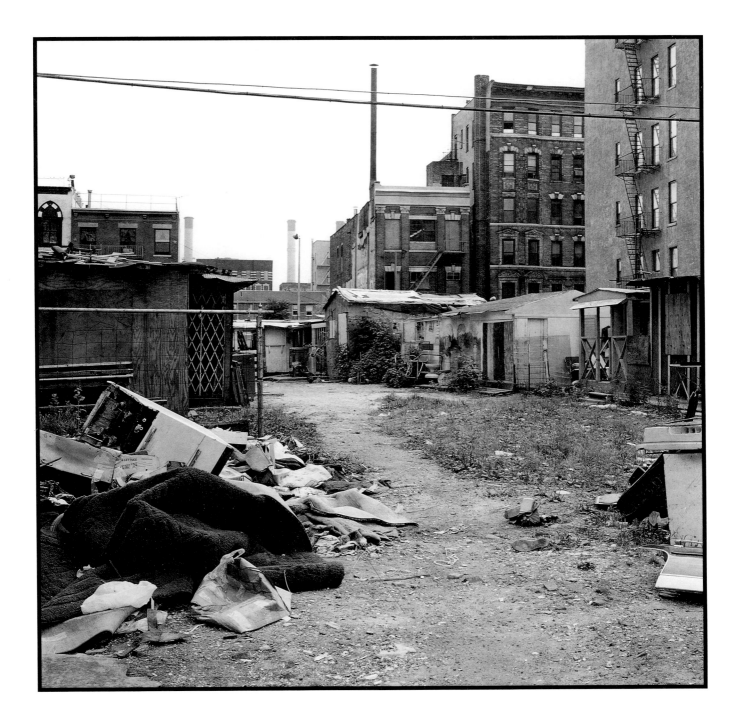

95 *Bushville*

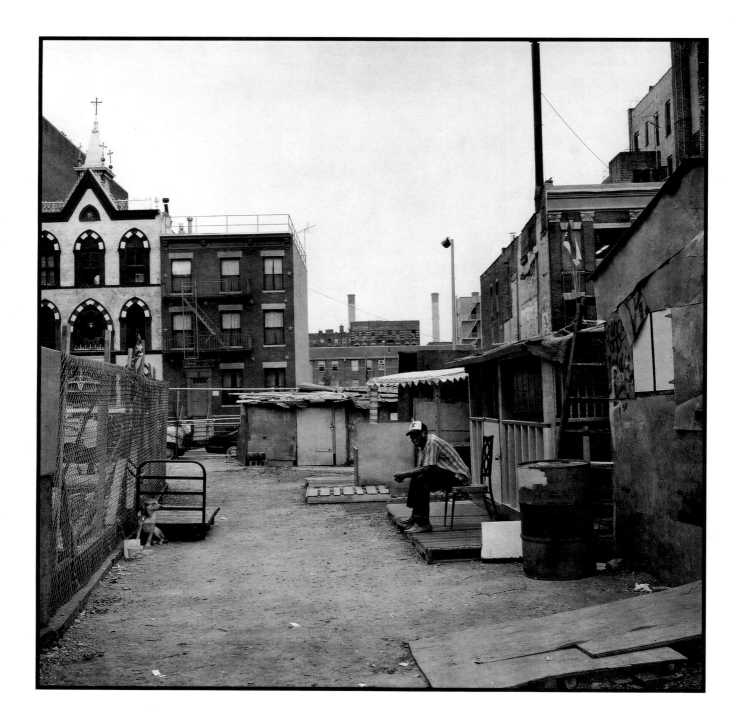

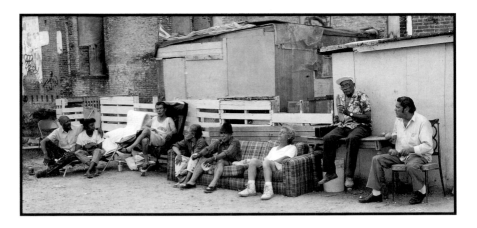

dumping ground of the residents of the neighboring tenements, and the Bushville residents complain about this eyesore. They see it as a symbol of lack of respect for the work they have put in to make the lot clean and attractive. Nevertheless, while they continue to grumble, they also use the heap as a source of building materials and furniture, that is, before it reaches the monumental proportions that trigger its removal by the Sanitation Department. But the trash heap, whatever its size, serves to conceal to the passerby the ordered and swept interior environment of Bushville.

While residents in the larger neighborhood also complain about the trash, the people in the projects around the lot, in fact, interact with the homeless on this site and join in the Fourth of July celebrations. Another of the nearby residents, Diaz (nicknamed Chabello), does much of the vegetable gardening on this site. Jenny, one of the women from the brick tenement, grew the tomato plants in the padlocked garden.

Guineo's Garden

Guineo's garden sits on a vacant lot in Bushville. It presents a three-part composition of house, courtyard, and small, exterior garden. But it is its adaptation to the seasons that makes this tripartite composition most interesting. The wire fencing on top of the wooden fence gives the courtyard the flavor of a garden. Behind the fence and protruding above it, the frond of an inflatable palm tree that Guineo found in the trash peeks out; it is a prize find, greatly admired by everybody on the lot. In the courtyard are a bucket and a plastic container that Guineo uses to carry water from the fire hydrant to his house and garden. Here we also find a broken statue of a sitting child. All of the courtyard's objects are artificial: the palm tree, statue, chair, bucket, plastic bottle, brick path. Guineo has used bricks set in earth inside the courtyard, but he did not have enough to finish covering the ground; in those unfinished places small stones and broken twigs have been strewn over the soil.

Guineo uses toys in his garden. Two railroad cars from a rather large toy train sit atop the fence, and wedged between the wires of the fence is a small toy horse suspended half in and half out. Rocks painted blue with a white border edge the planted areas of the garden.

In the composition of the garden, the house wall presents an interesting element. The entire wall has been taken over by an enormous painting Guineo found in the trash; the painting, perhaps by a student from the nearby art school, is of women's heads against a blue sky, orange earth, landscape background. The heads are arranged in a traditional, nearly classical, bustlike format. The canvas was an important find from one of Guineo's scavenging expeditions.

Guineo spends much of his time roaming the streets looking for construction materials and objects for his garden, courtyard, and

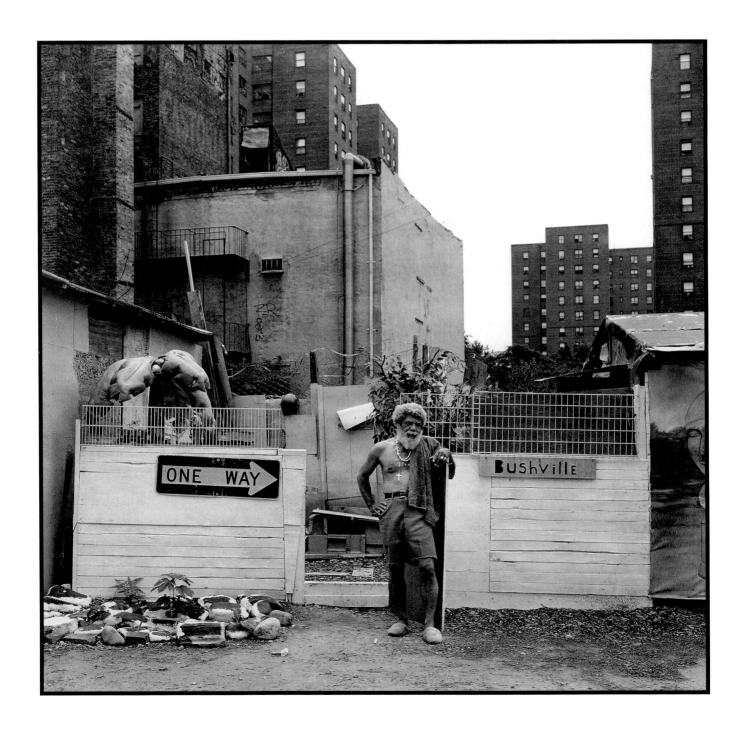

99 Guineo's Garden

house. In addition to his palm tree and canvas finds, he also salvaged the broken statue from the sidewalk trash.

I carry all these things here myself from the street, from everywhere, found them on Eighth Avenue, First Avenue, every piece of wood, I found it. Everything I found I take it. Little by little, everything. I carried it all for more than two years.

Guineo changes his space seasonally. The entrance to the garden was extended to both sides of the fence once summer began. The plants in the front garden are *Cimicifuga simplex,* also known as bugbane. As its name implies, this plant is popularly believed to keep bugs away. In July, he added an umbrella to the courtyard. By steamy August, he built a roof over the courtyard for shade but left it open to catch the breezes. Also by August, the bugbane plants in the rock garden had grown considerably, reaching the height of the fence, and Guineo had planted an additional area. Part of the work of the summer was to make a radial, flowerlike design on his fence with a clothespin wheel. The wheel served no useful function; it was purely decorative. The rest of the fence top was made from refrigerator shelving.

I have to think of something to keep this place [warm]. This [porch] roof not ready for the winter. I have to make it better. I could invent something you know: [the ideas for them] come in your mind, and you could have something different everyday. Nobody know, right? This is my work: I can't work here, I can't work there. This is something I got to do [with] my life. I figure if I don't do something here, my mind will die. I have to keep doing something here. I am my boss because I know what I have to do, what I need, what I don't need. If I need this, I go to the street anywhere, . . . and I take it over here. I have to do that. I don't know other people, how

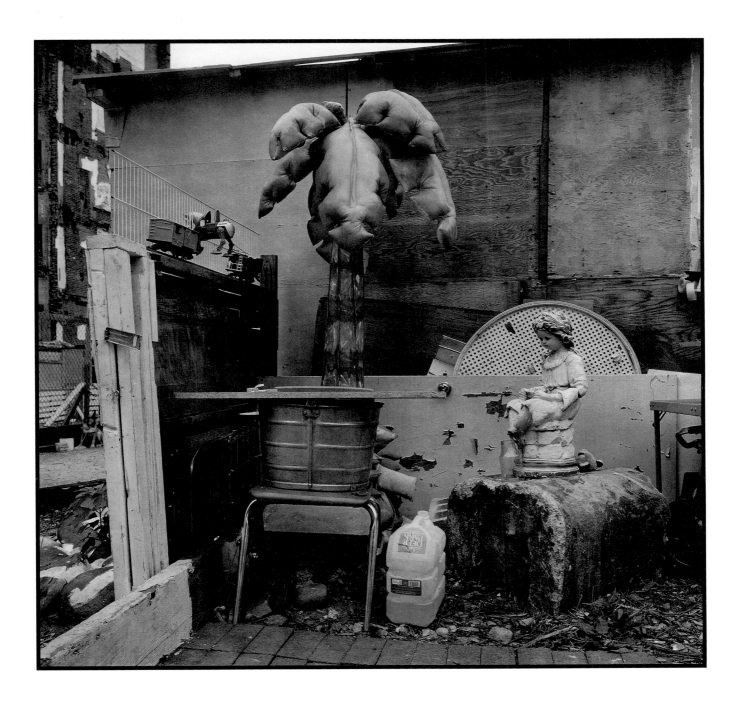

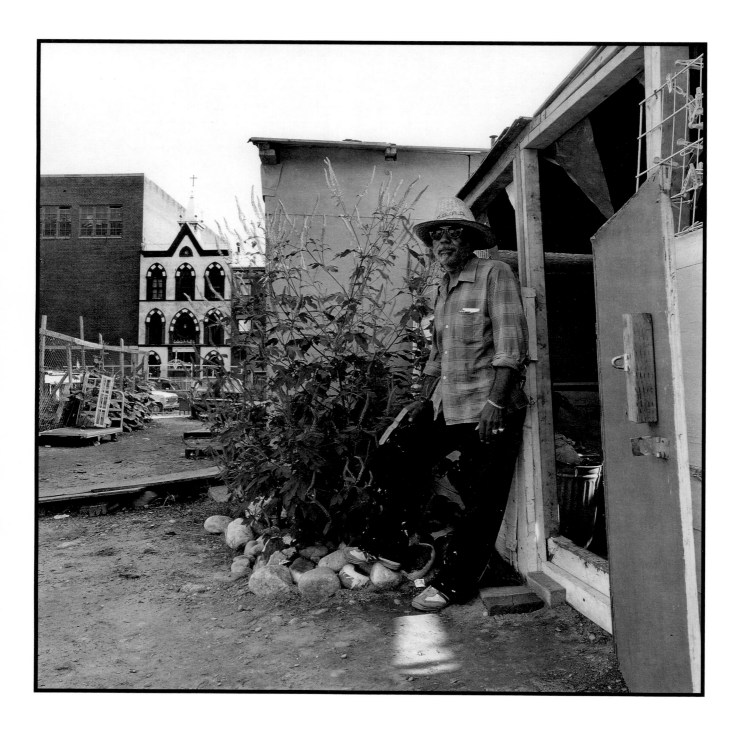

they do it. I think I gotta do this, I like it. I feel good. It is exercising for me. This is something important, for myself. This is the first time I do something for myself. I don't know if I'll finish this, you know. I am not gonna stay here the rest of my life. Will they put something here for the people working hard; they suffer making the houses here, you know. I don't know who to tell my problems. I don't say nothing to nobody because who cares. I don't care. I am on to fifty-five, too much for me; for me it's like a hundred. The people they come to check, they say: who's the peasant?

A new building effort started at the end of the summer. Standing with a saw, Guineo can be seen against the very tall plants of his garden.

In the fall, the roof was enlarged to offer greater cover, but the fencing at the top remained open. By late fall, when the planting and growing season was over, a wooden platform for buckets and containers was moved from the front of the planting bed to the front of the fence. As winter approached, Guineo enclosed the whole courtyard by putting boards up to the roof behind the fencing. The prized palm tree was donated to Pepe, a friend and neighbor, and the courtyard space became an interior living space for the cold season.

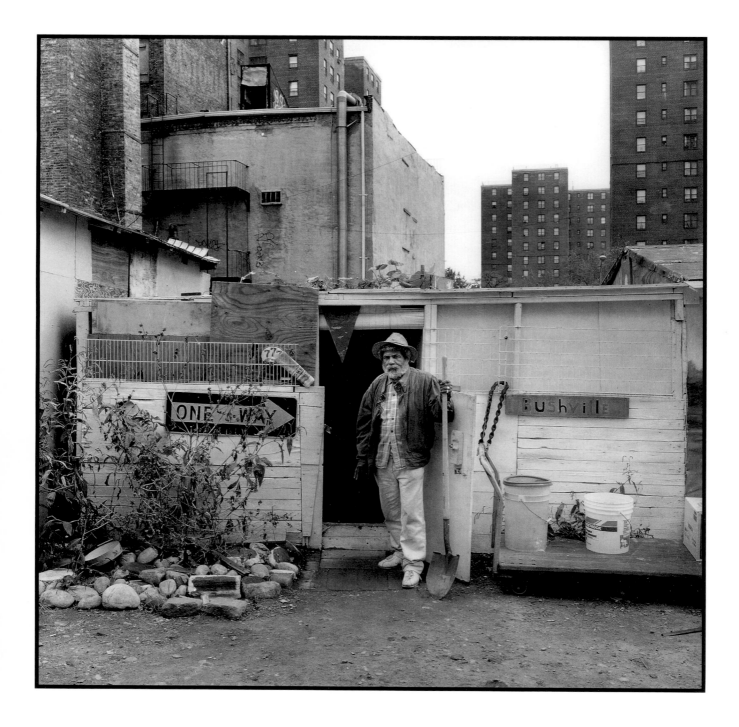

104 Bushville

The interplay of open and semi-enclosed, garden-courtyard and house, natural and artificial, bugbane and inflatable palm tree establishes a transition between spaces (here, from exterior to courtyard to interior) often sought by accomplished garden designers. Guineo's whole composition is contained in a frame created by the white of the fence boards and the stone edging.

But the most striking effect here is Guineo's use of seasonal, material changes to reinforce the essential transitory nature of his three spaces — garden, house, and courtyard — on this lot. Set against the illusion of more settled conditions created by the statue and imitation palm tree, these movements, additions, and subtractions — possible only when one's possessions are few — make clear the realities of Bushville. Yet Guineo makes transience, impermanence, into something positive: the virtue of adaptability.

Over the winter, a shopping cart has been added to Guineo's space. A second planting has taken place. On one side, the planting is surrounded by a simple string fence tied to four corner bars. The fence has acquired small animal heads. It forms a recess in front of the shelter. In it also hang a real pineapple and a plastic plant.

Guineo's Puerto Rican background is evident in the way he constructs his space. His use of the courtyard, the bright colors of stones and murals, and the precious inflatable palm tree that dominates the courtyard clearly convey a rural island image, noted by the passerby who asks Guineo, "Who's the peasant?"

Guineo sees his garden and dwelling as tasks for his life. Stimulated by the seasons, he changes these areas constantly and reinvents them: *The ideas for them come in your mind. I could invent something, I could have something different. What you think? Next time you come back you see something different? I wish to try to do something different.*

His inventiveness is reflected in the photographs, which capture the changes over time. These center on the double role of his courtyard: the exterior part of interior space. In spite of his hopeful statement *(I think this is my breakthrough to stay here)*, there is a deep sense of the impermanence of his creation: *They have to drop this house down. . . . They going to chop the houses down. Who will come to tear me down?*

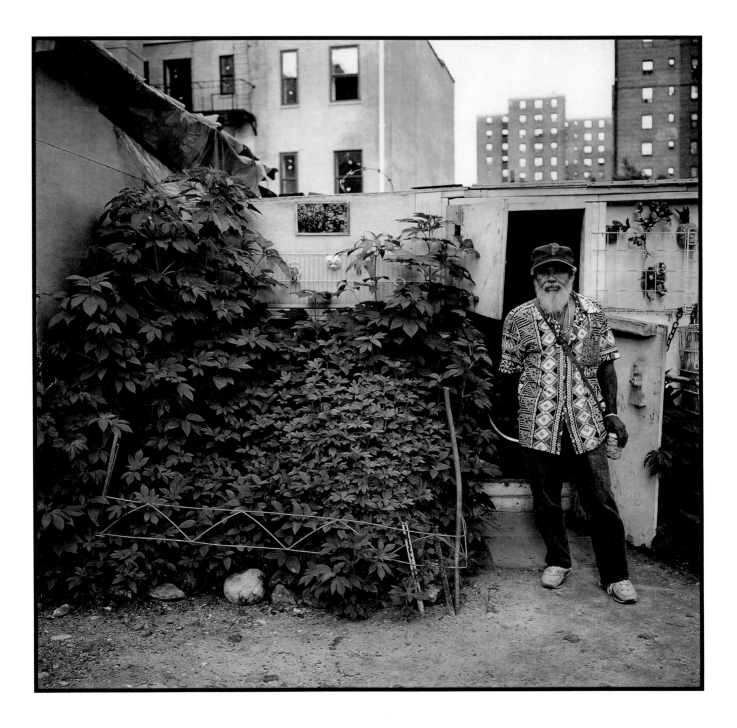

107 *Guineo's Garden*

Chabello's Garden

From the street, the only part of Chabello's garden that can be seen is the fence, made of two dozen skids set end to end. Juan, a friend of Chabello who is also involved in the garden, is seen in the photograph standing to the right of two other men. To the left , Juan's house leans against the wall of an abandoned tenement building, which it uses as its back wall. But Chabello does most of the gardening here, and it is he who decides what gets planted. Chabello does not live in Bushville and he is not homeless; he lives in a nearby apartment. He can be seen here tending his beans. In the rear, to the right, squash plants are growing. In a later photograph, the garden has been subdivided, more skids have gone up, and a new section of garden has appeared. It is planted with beans, peppers, and okra.

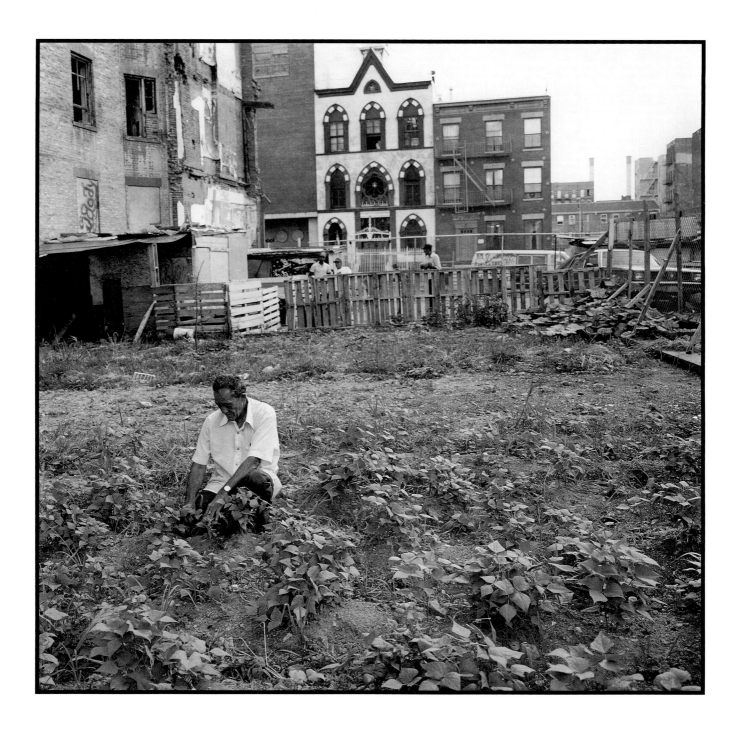

109 *Chabello's Garden*

If Guineo was responsible for naming Bushville and establishing the site's spatial organization, another resident determined the character of the central passage between the houses lined up on both sides. By the many changes he made to his own front yard, changes that influenced the work of others on the site, Pepe Otero shaped the development of the site's main spatial feature so that it became a community walk.

At first, the various houses along the side acquired front yards of skids, carpets, and plywood, and chairs and carts were placed in these yards. Then, gradually, by Pepe's example, a long, continuous set of skids was put down in front of the line of dwellings. A central walk thus emerged. This walk became the much-used shortcut for the neighborhood. The busy sidewalk, which has a particular flavor of Latin cities, requires for its upkeep the cooperation of all the residents living along it.

Pepe is one of the most stable residents of Bushville. Though he had a drinking problem when he arrived on site, he has been "dry" since 1991. Pepe's last name is Otero, which he explains means "watchman." *That's what I am. I watch out for everybody here, but nobody watches out for me.*

In the first version of Pepe's yard, seen here, the porch is topped with a turquoise blue-and-white-striped canopy. In front of the canopy is an umbrella, offering shade beyond his porch. On the porch is Pepe's large cassette tape player, which is connected to a tuner inside; he plays Caribbean music and Argentine tangos. The yard in front of his house is made with skids; it serves as his porch, but it is also the first iteration of the long, central walk. The porch, which is quite detailed, looks directly onto the fenced garden made by Chabello. Stonework interrupts the skids in front of the umbrella

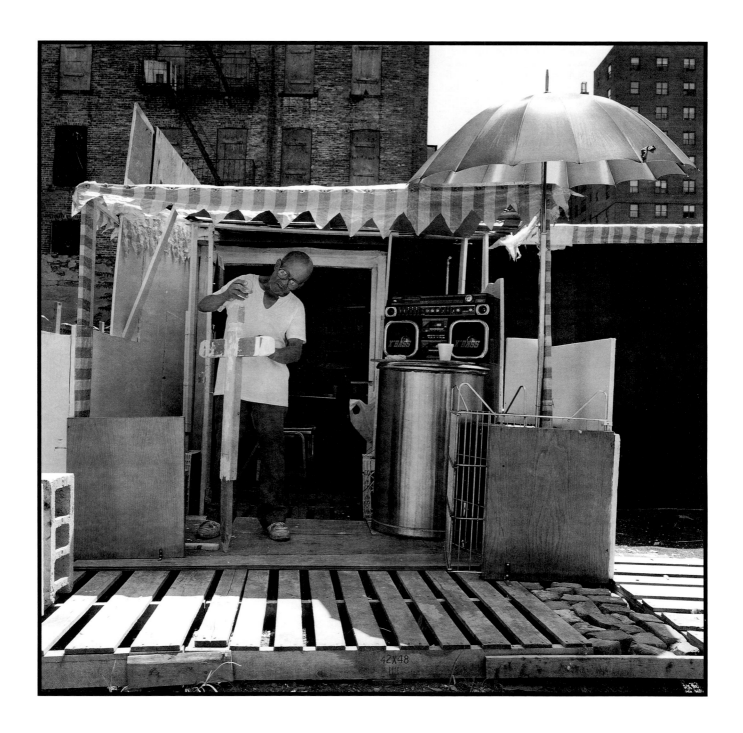

111 *Pepe Otero and the Community Walk*

and provides a separation between the living space and an open-air carpentry workshop. The concrete blocks on one side of the porch are used as porch seats.

Pepe's porch is set off from the front path by refrigerator shelving used as a fence. The skid that marks the end of the path is painted white. In Pepe's courtyard we find Guineo's famous palm tree, relocated here after Guineo enclosed his own courtyard.

In the next stage of development, the semiprivate porches or ramps of both Pepe and Guineo have been joined into one long, communal path, which, fronting the large garden, connects the houses in a new way. Guineo clowns on the path, his beard shaved. In the background, Pepe's cart is parked in front of his porch as if it were a car. The real car, farther back, does not run but is considered an important piece of property. In the foreground, a mat placed on top of the path redefines the entrance to the space of Mario, another resident living along the communal path.

In November of 1991, Pepe's porch becomes enclosed too. The canopy is gone, the roofline is now solid, and the interiorized space has acquired three star-shaped windows. A green mat covers the skids, making for a more solid path and semipublic space. In the spring of 1992, Pepe starts to extend his roofline over both the courtyard and his front walk. Continuing to make his exterior space more private, Pepe constructs a fence of red plastic bread trays along his front walk.

The final step in the making of Pepe's outdoor space is the extension of his porch. It has become a portico, which stretches his front yard all the way to the fenced garden. At the same time, it makes an important covered gallery for the central pathway traversing the

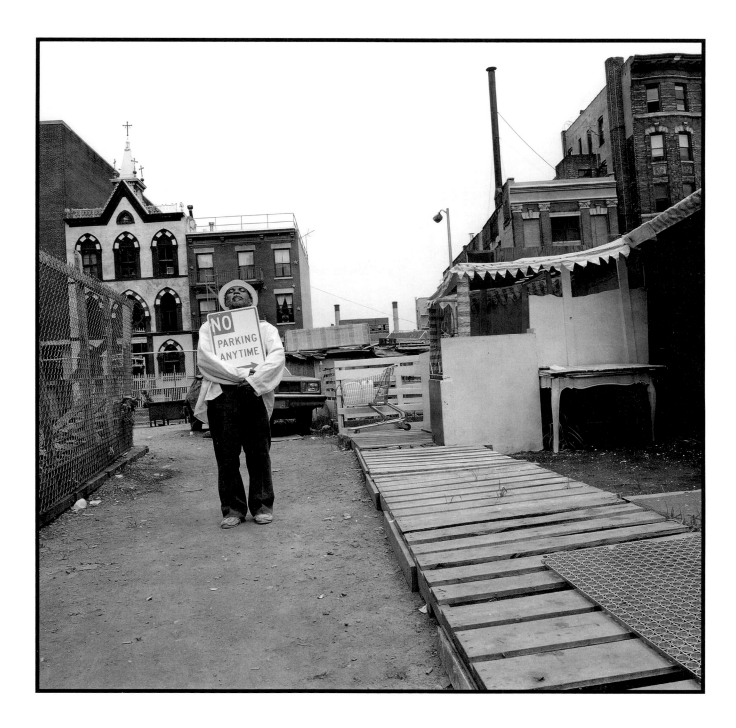

lot. It is carefully and handsomely constructed of the red plastic bread trays in a wooden frame. Semitransparency, perforation, and color give it a festive character.

Pepe, who sixty-seven years ago was born Jose Otero in a small town in Puerto Rico, has lived in Bushville for two winters. As a young boy in Puerto Rico, he learned some electronics and was trained in bookbinding. With this training, he got a job at a printer's while in high school; later, he took a job as a typesetter in San Juan.

From San Juan, I came to this country, because somebody told me I could make lot of money in typesetting. When I came to New York, I got big, bad surprise, because in those times, the minimum salary was thirty-four dollars a week. I was making more money in Puerto Rico than here.

Pepe tells us that he fought in the Korean War. *Now I kill rats with my slingshot.*

For years Pepe was employed in fixing lamps and making custom-made bases. In 1957, he had a bad accident on the buffing machine, fracturing his right arm in two places. In July 1991, upset with his employer's lack of respect, he quit his job.

While he was working, Pepe lived in a room on First Street and First Avenue: *It was no good, and the rent was too high. Seventy dollars a week. You could barely walk in the place. They was in line on the stairs to buy drugs.*

After a fire in the building, Pepe decided to leave and moved into Tompkins Square Park for six or seven months. He preferred the park to the rooming house because *it was up to me to keep my surroundings clean.*

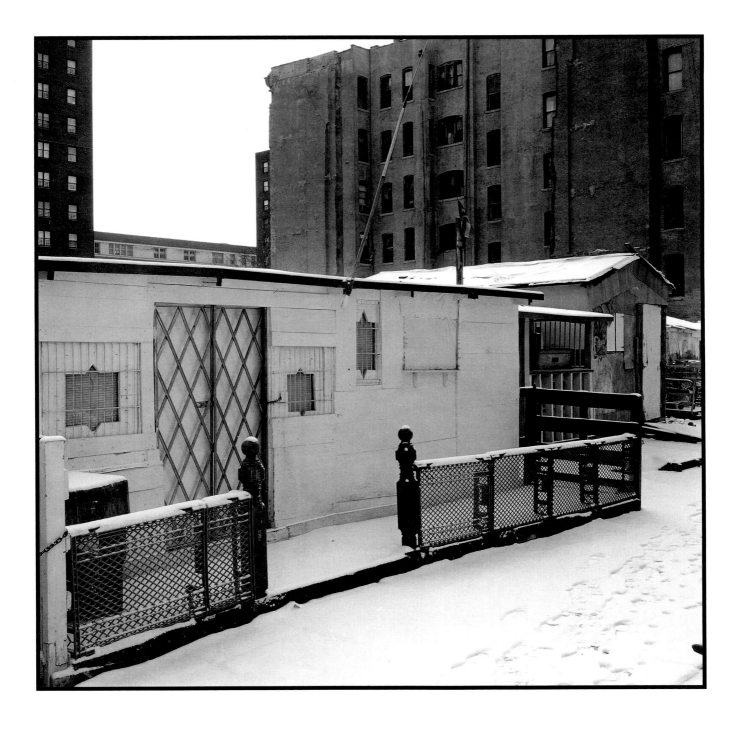

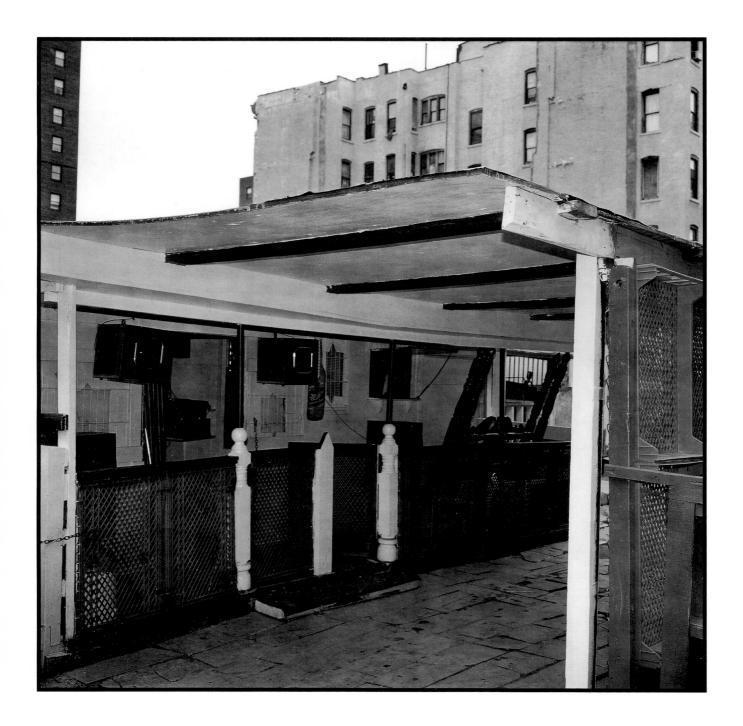

116 Bushville

I'm an old man, I collect my old man check. The check is not enough to pay a rent. That's why I'm here.

Pepe moved into Bushville in the summer of 1990, taking over the house of a friend who was leaving the area.

[When I first came here] I was planning to build a little shack to clean this place, to park my car. Diaz cleared the lot. . . A friend of mine start this [place], and I improved it. Everybody want it.

Underlying Pepe's space making, with its communal overtones, is a sense of order and stability that is not often a part of the lives of Bushville residents.

Pepe tells us something else about Bushville: *It doesn't matter what time I go to sleep. I wake up at five in the morning. The birds wake me up.*

Lisette's and Monín's Garden

Lisette and Monín rent a dwelling from another Bushville homeless person, who built himself a larger house on the same lot. Lisette and Monín decorated the facade and created the garden. Within the garden is a smaller rock garden consisting of painted rocks. One section of the larger garden has live plants, and another has dried and painted branches. Broken statuary and hanging plants decorate the narrow porch of the house. The porch is closed off from the exterior garden by a white painted gate and white wooden frames with cross bars. To one side of the house, another gate, made of white metal, closes off a courtyard space, which became a patio when a floor of plywood, covered with vinyl tiles, was laid down. The garden is reached by two carpeted steps leading down to it. Another step, covered with carpet and held down by stones, leads from the patio to the front walk.

The porch and front garden are composed of a minimum of elements. But the material, while scant, combines the live and the artificial or inanimate: dried and live branches, live plants and rocks; this interplay can be seen in the closeup, where dead branches and live marigolds are mixed.

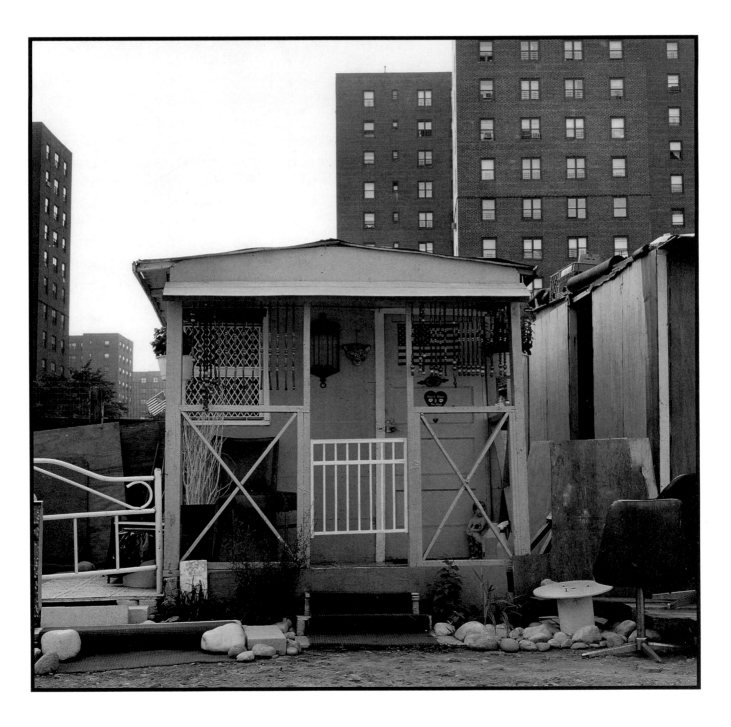

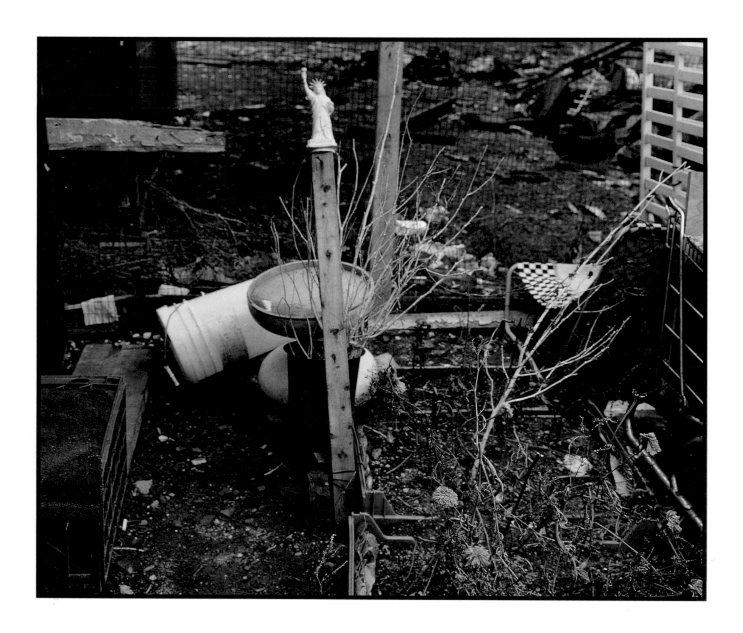

Each of the planted areas is, in fact, a crate filled with earth. A post in between them sports a replica of the Statue of Liberty, and by the post a pail supports a basin holding water: a birdbath. A chair sits against the fence in the corner of the postage stamp garden.

Lisette and Monín moved out, and Jesús moved in. Jesús had no interest in the garden and the front yard, and he let both go to ruin.

The Hill

The Hill is an area adjacent to Manhattan's Chinatown. It lies on a shoulder of the Manhattan Bridge, but it cannot be seen very clearly by the thousands of cars crossing the bridge. In a *New Yorker* article published in 1991, James Lardner remarked that The Hill bore a *"resemblance to the great shanty towns of Manila and Rio de Janeiro."* But not all residents in this community are homeless or disaffected: the tepee sticking out above the balustrades of the bridge was constructed by Gabriele and Nick Manhattan, two artists who formed Thieves Theatre, a company whose purpose is *to embody and articulate the voice of those who are stigmatized, quarantined, disenfranchised and to lift the barriers between us and them.*

The Manhattans live on The Hill, though they have an apartment in Brooklyn. *We're researching our lives while we're living there, and we're looking at the reactions of people on the outside — to us and everyone else.* The reaction to their choice was, in some quarters, quite clear: who would ever want to live here? In fact, a detective investigating one of The Hill's fires was quick to say that in his opinion choosing to live here was not rational behavior.

The two artists started a small garden in The Hill with Gabriele's planting of a few seeds in the spring of 1991. Gabriele's garden was the productive kind: she grew tomatoes, basil, peppers, and an assortment of flowers. In a small corner, passed daily by countless cars, the garden grew rapidly. Many residents of The Hill helped to maintain it and shared in its harvest.

Gabriele's first garden consisted of vegetables, flowers, a large stuffed bear, some rocks, and two ailanthus trees. The plants grew into a large mass of greenery, competing with the two ailanthus trees, which served as an edge to the garden. One of the residents of The Hill has his dwelling in the background; two chairs and a flag sit by the side oriented toward the garden. In it, the stuffed bear, Wild Thang, reigns.

Well, after the winter, when there was still snow on the ground, I started thinking about it. The idea was to change perceptions . . . and the way to change perceptions is to make it prettier. I really wanted something beautiful out front and . . . something for people to look after . . . so I started the garden. Everybody . . . was very excited about it, so Nick cleared the whole area at the entrance. Then Nick and Louie took the seeds I had bought, flower seeds, and started planting. Louie was sort of drunk. He planted those suckers five, six inches deep, so, of course, they never came up. It was way too deep. But we waited anyway. I waited for about a month, just to see if anything would come up, and I also did some more work on the soil because they didn't really get enough of the big rocks out. Then we went out and got some seedlings and planted them, and I weeded out everything except what I thought might be what Louie had planted. And sure enough, two miracle marigolds came up from Louie's crop. The rest were — I can't remember the names of the flowers. Unfortunately, I lost that little plastic instruction stick. . . . But basically I just planted anything that was cheap. We just kept our eye open for cheap plants that didn't cost two or three dollars a shot. Then we saw some at this farmers' market in Brooklyn for six for a buck, which was perfect. We also planted cayenne peppers and . . . tomatoes, cherry tomatoes. Meanwhile we got some horse manure from police horses off the street. One of the guys up there, Billy, that was his idea. "I'm telling you, horse manure, get some horse manure." So he and Nick went with a shovel and a bucket and got some horse manure, watered it down and threw it on there. Then we

125 *Gabriele's First Garden*

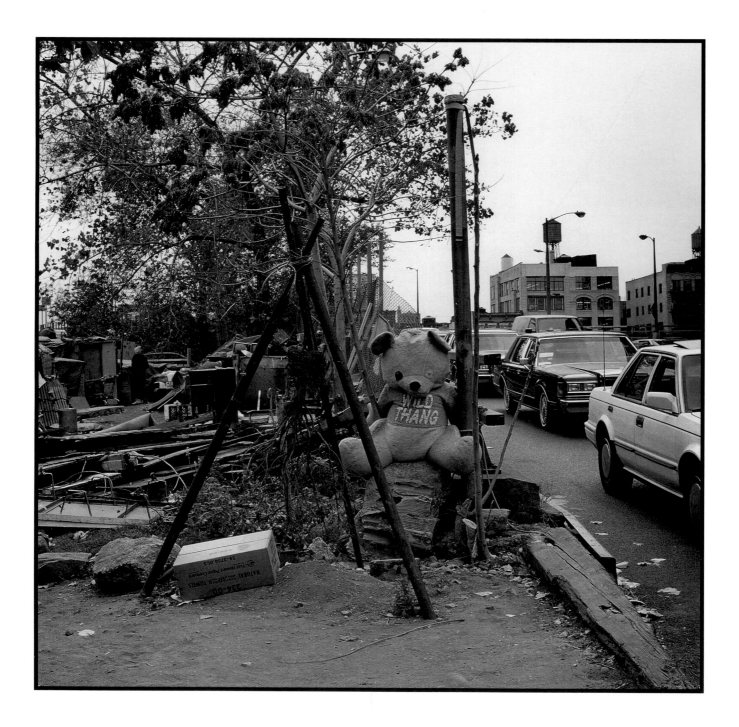

got some sawdust, just to loosen the soil up. And then I bought some liquid fertilizer that you dilute with water and put it on there once a week, and the end result was incredible, because the peppers, tomatoes and everything grew amazingly well. You'd never have believed it, looking at the soil. And then other people added plants to it. Billy, he added an office-type plant. Someone — I don't know who — put a basil plant in there that grew incredibly well, too. Coco — you met Coco — she put in a house plant that she had inside that was dying. She's the only one who's still around that I know contributed to the garden.

We got some sod from a friend of ours who was making a film. He was freelancing as a production assistant on a commercial set. When these commercials are done shooting, they just throw everything out, so we got the sod. Everyone helped. . . . A guy called Red worked really hard laying it. Louie kept an eye on it. Red, he's one of the original people up there, he really prided himself on watering it, too. Anytime anybody was throwing out water, they would try to remember to throw it on the garden. Garbage would blow onto it, so I would go in there regularly and keep the ground clean.

Sammy, he never really did anything inside the garden to keep it up, but he always liked the peppers, the very hot peppers and the tomatoes. It took people a while, you know. We told them to go ahead and help themselves. It was funny at first: they would come up to me and rat on other people. And I'd have to say, oh, that's fine, that's alright, take whatever you want. It's yours. Just take it. And so, it took a while for that to sink in. As for who actually did take it, I don't know. But whenever I was there, there were never any ripe tomatoes, and there were tons of tomatoes on the vines. After a while I think people just helped themselves.

On November 7, 1991, three of the shanties burned to the ground, and the garden was destroyed. But the shanty behind the garden

was soon rebuilt, and the remains of the garden became a burial plot for a favorite pet of Sammy, one of The Hill's entrepreneurial residents and the first person to bring electricity to the site. Sammy's puppy had gotten run over in the street immediately after the fire and the destruction of the garden. Gabriele's neighbor, Louie, painted a sign reading "Princess" for the dog's burial site in the garden.

When the fire happened, when the puppy died, there was a period where Sammy was completely silent. Then came the self-mocking . . . oh Princess, my poor Princess. . . . Then there was anger for a while and "I'm gonna find out who did it". . . but then everything was forgotten, and he immediately and decisively got back to work on rebuilding. And that's the kind of thing that I found so amazing. You never really see anyone upset in the sense of sad or depressed. Angry, yes, definitely angry. But you never see any self-pity. Nobody ever gripes, nobody ever bitches, nobody ever cries, nobody ever despairs. I'm just in awe of that. Not in the entire time that I've been up there, did I ever see anybody ever become bitter or indulge in some whining for a while. The way I do. The way anybody I know does — about the fucking system or this or that — it's not even an option. Their lives are too hard. Most of the people up there live a very Zen-like existence, from minute to minute, hour to hour. They don't know what's going to happen tomorrow or even later on today.

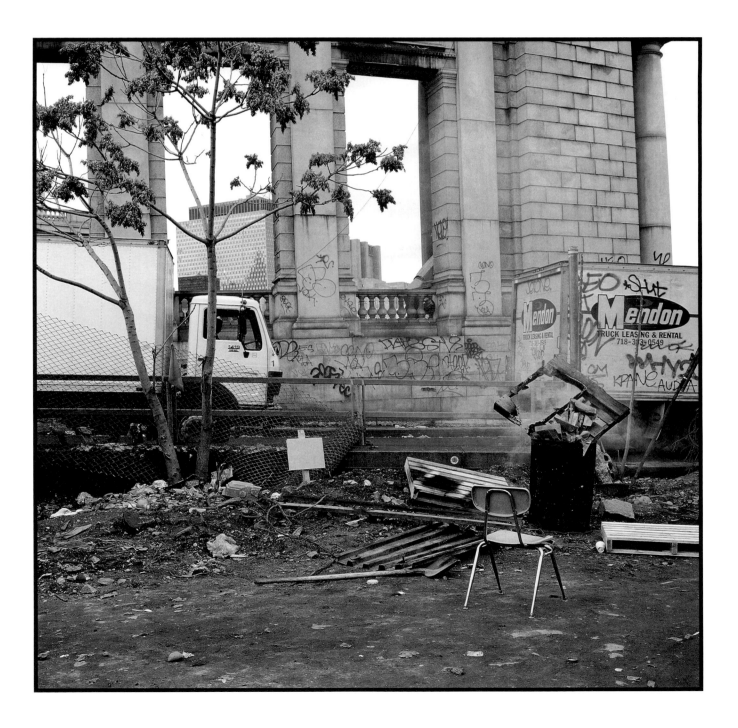

129 *Gabriele's First Garden*

Gabriele's Second Garden

In April of 1992, Gabriele planted a second garden. This one has many different kinds of peppers and cherry tomatoes. The garden uses the rocks from the lot for edging. In turn, a wire fence edges the rocks. Tied along the top of the fence are strips of old sheets, knotted together. At the unfenced ends, the sheets are anchored to the chainlink street fence at one end and to the trunk of an ailanthus tree at the other. White plastic spoons are placed along the furrows; these identify the seeds. At the back of the garden, a small sign reads: "Please don't step on the dirt. We are growing a garden." After this garden was planted, a series of small plantings took place on The Hill.

In this second season, the ailanthus trees that survived the fire have not yet put out leaves. Wild Thang, the guardian of the earlier garden, is nowhere to be seen.

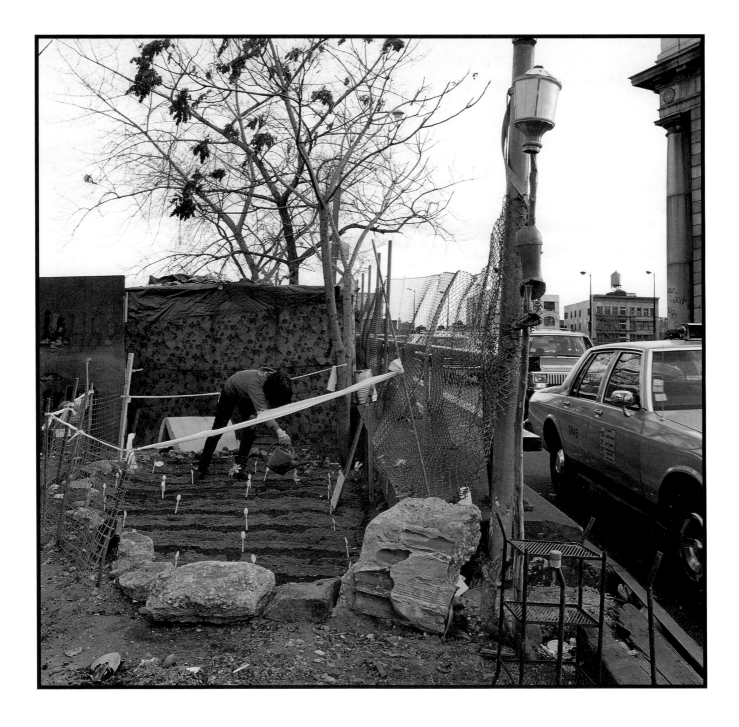

131 *Gabriele's Second Garden*

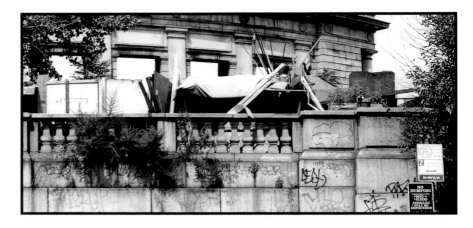

Louie's First Garden

By the stone balustrade of the Manhattan Bridge, to the right of the tepee, part of Louie's garden can be seen. On the Bowery, Louie has bought tomato plants for fifty cents each, and he waters them with a teakettle. One of his cats, his "babies," is by his side.

Louie was one of the first of the residents of The Hill to become interested in the garden. He helped Gabriele with her first garden, though his seed planting did not come off. In his garden, he has tomato plants only. They are planted in discarded fruit boxes that have been filled with earth.

Louie's cats live fragile lives here. They are often killed by the traffic coming off the bridge. Louie has made a graveyard for them on the site. Snow's memorial is right beside Louie's dwelling.

On the ground of the garden, amid the debris of the fire, are the ever-present skids, which serve so many purposes in homeless communities.

Louie is one of the earliest residents of The Hill. He belongs to an era of homeless alcoholics who lived in the vicinity of the bars on the Bowery and who drifted here when the bars were closed.

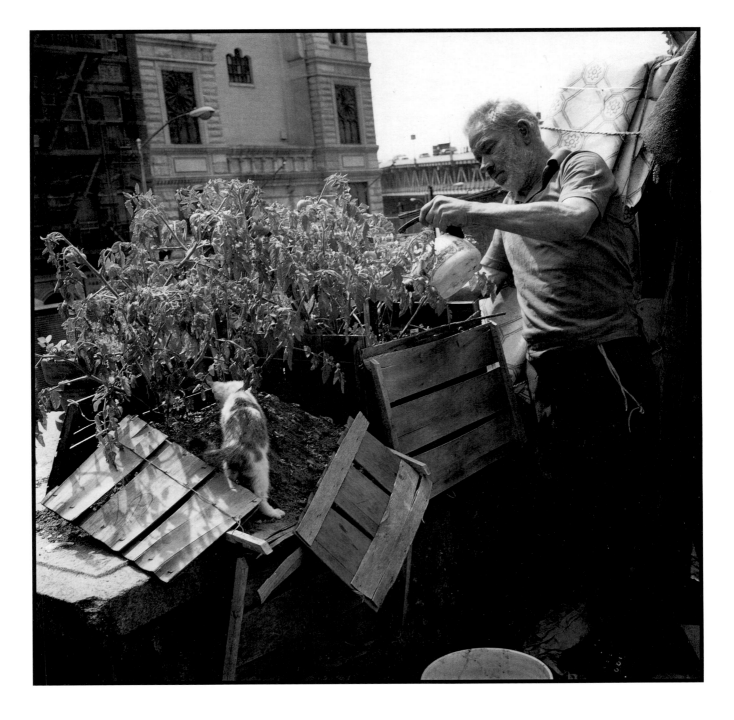

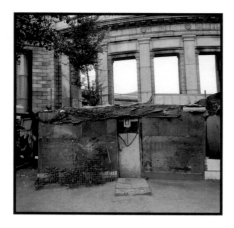

Ivan's Garden

After Gabriele started her second garden, Ivan, a Puerto Rican resident of The Hill, began his garden, building a small planter for his one flower bulb, a tulip (to the left of his dwelling), and laying paving stones in front of his door. In the early spring, he added a fence and some leftover peppers from Gabriele's garden. These Nick helped to plant in Ivan's area. The placement of a fence in front of the plants extended Ivan's front yard.

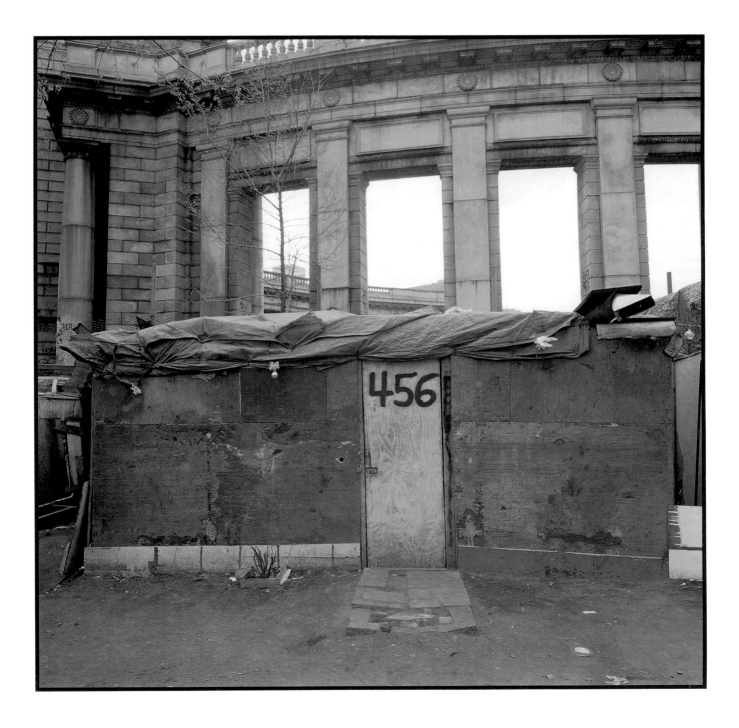

135 *Ivan's Garden*

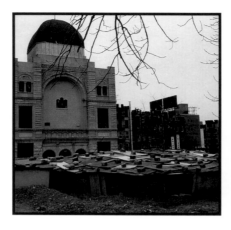 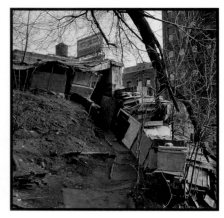

The Chinese Man's Garden Path

Unlike the rest of the inhabitants of The Hill, the Chinese man, nameless because he keeps to himself and never speaks, has a private access path to his hut from the street. Only he is allowed to enter there. Anyone who tries to take a shortcut through the hole in the fence is intercepted by one of the residents and sent around to the main entrance of The Hill. The Chinese man comes and goes through the small opening in the fence, which forms an entrance to his space. He has laid down a carpet to make a curving path, and there is a yard where he has a grill to make his morning tea. Skids, chairs, boxes, and doors make a wall along the path and keep it private; the wall is also a place for storing materials for needed additions to his house and yard. In summer, with the trees in leaf, the area looks sylvan; in winter, stark.

The view from above and behind the hut shows that the roof is made of metal shelving held down by stones and granite pavers. The effect of the stones on the roof and of the very low wall makes the hut seem to merge and become one with The Hill. The roof recalls the stone-anchored slates or sheets of galvanized metal of roofs in small towns in windy regions of the world. Although it is larger than the dwellings surrounding it, the hut rises only modestly above the ground, its space having been dug out from the earth. It is, therefore, barely visible from the street below. The Chinese man frequently sits on his roof. From there he observes the activity on the rest of The Hill.

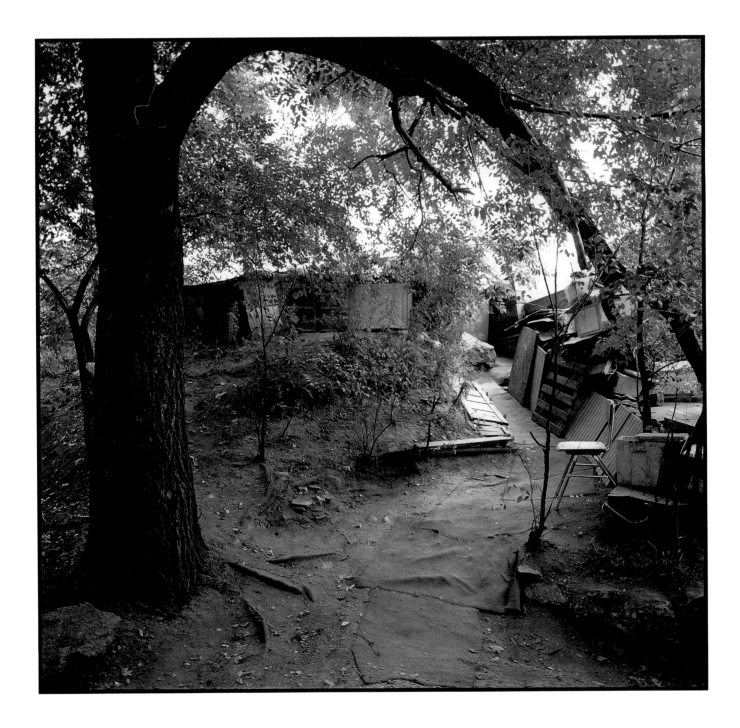

137 *The Chinese Man's Garden Path*

Mr. Lee's Garden

Mr. Lee also began a garden after Gabriele's second one. It consists of a few tulips, a watering can, and a cup, all tightly packed by the edge of his tent. It is a true miniature garden, not much more than the bunch of oranges tied to his tent for Chinese New Year.

Mr. Lee's tent is situated among the twenty other dwellings in The Hill. There are, besides Mr. Lee, Louie, and the silent Chinese man, a few Hispanics, among them two handsome, well-dressed young women who work as prostitutes and live with two male residents.

When a second fire swept The Hill at the end of May, it completely burned three dwellings and damaged several others. Mr. Lee was found dead inside his tent, which was one of the structures consumed by the fire. The week after the fire, the site was overrun with detectives and investigators. The Chinese man sat silently on his roof, looking at the city officials combing the site. A few days later, someone was arrested and charged with arson and murder.

One of the residents made a painted sign and placed it where Mr. Lee had died.

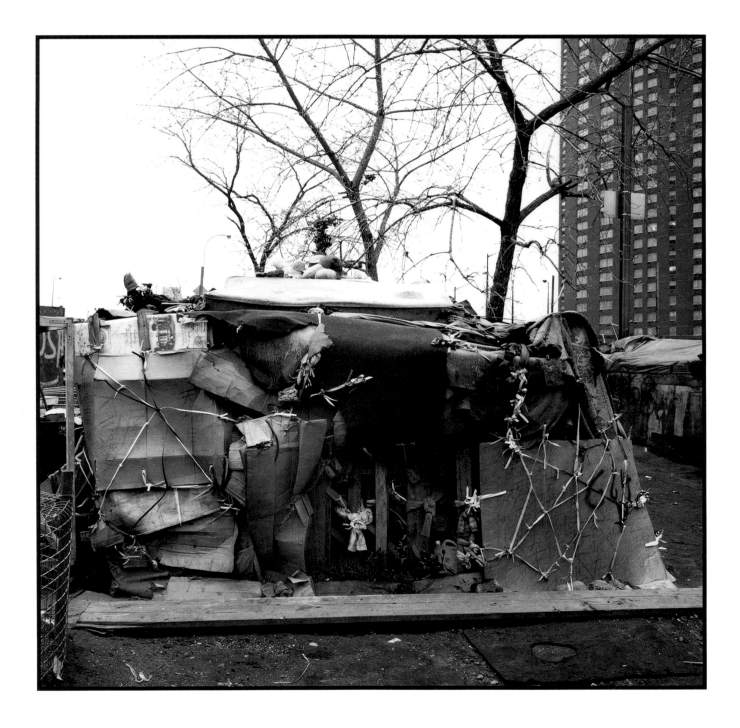

139 *Mr. Lee's Garden*

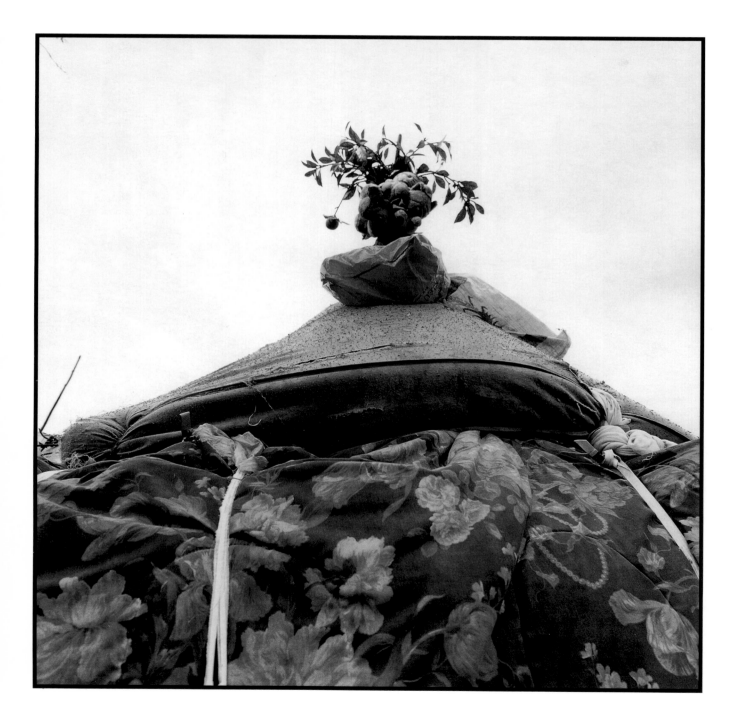

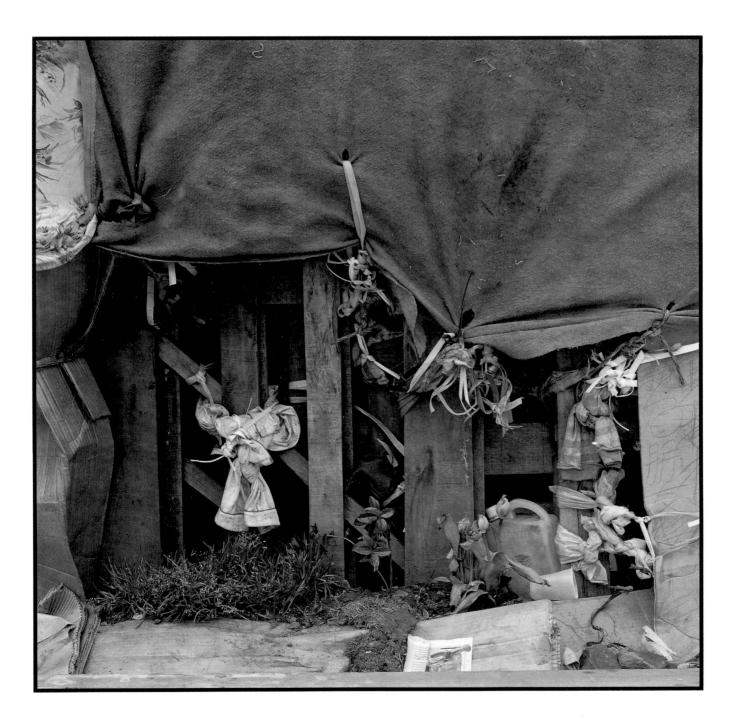

141 *Mr. Lee's Garden*

Louie's Second Garden

After Mr. Lee's death, Gabriele came to The Hill infrequently. Her garden grew rampant. By the end of the summer, it had been cleaned up: Louie had started to take care of it.

I started working on the garden . . . the reason why, see, Gabriele worked hard on it. When she planted it in the spring, she used to come up every couple of days and weed it out and clean it up. She had pepper plants, tomatoes, big peppers, long, skinny Italian peppers, hot peppers, cherry tomatoes. And then after the fire when the Chinese man burned up, something happened. . . . She got discouraged or something and she didn't come back for a long time, and the garden grew up in weeds. Nobody took care of it after the fire. So many weeds grew up, plants didn't get enough sun or water, and people kept throwing in their garbage. So beginning September, I felt like cleaning it up. I took a look at the fence, fence all knocked down, so I decided the only way to keep it half-way clean was to try to reconstruct the fence up again. So I pulled a ton of garbage out of there and drove some metal poles in the ground. Did the best I could with them to put the fence up with whatever materials I had. Only one tomato plant [was] left. I staked that off the ground, and it started to give tomatoes.

Louie has continued to tend Gabriele's garden.

143 *Louie's Second Garden*

An Inventory of Garden Building Materials

 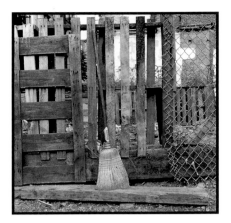 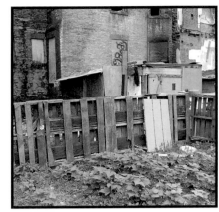

Pallets

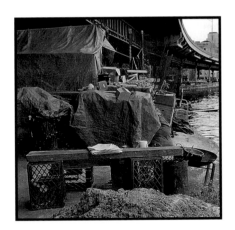 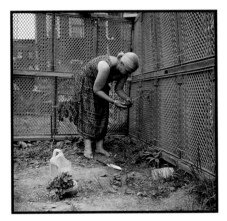

Milk Cartons and Bread Trays

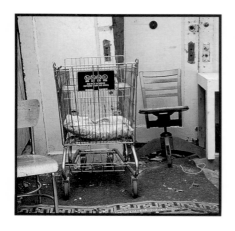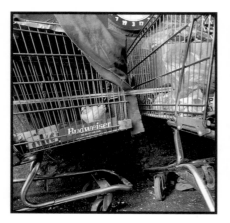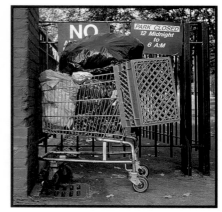

Shopping Carts

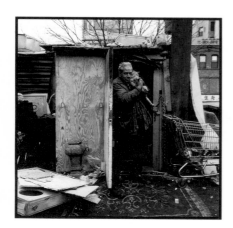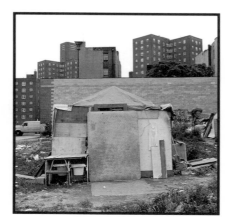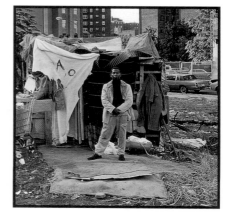

Carpet/Matting

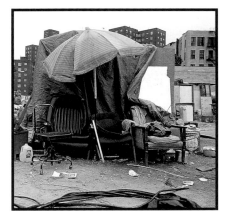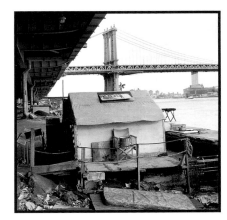

Furniture

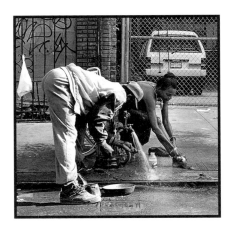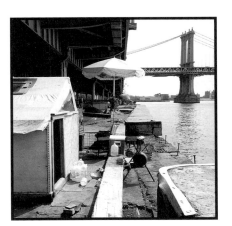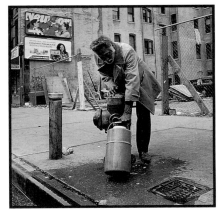

Water

Transitory Gardens, Uprooted Lives
was published by Yale University Press,
New Haven and London.
The text was edited by Judy Metro and
Lawrence Kenney, Yale University Press.
The book was designed by Margaret Morton,
and the pages were formatted
by Jacqueline Kessler, New York City.
The typeface is *Palatino*, originally cut
by Hermann Zapf in 1950.
This updated *Palatino* version was set with
a Linotronic 300 computerized system.
The text paper is Warren 80# Lustro Dull.
The endleaf paper is Champion 70# Benefit.
Production of the book was supervised by
Pam Smith, New York City.
The book was printed by Meridian Printing,
East Greenwich, Rhode Island, and bound by
The Riverside Group, Rochester, New York.

Margaret Morton's photographs were
made with a Mamiya 6, a medium format
rangefinder camera. The photographs of
Nathaniel's garden and the destruction
of James' garden were made with a Nikon
F3, a 35mm SLR camera.

The oral histories were edited by
Diana Balmori from audiotaped interviews
conducted by Margaret Morton between
1991 and 1993. Nathaniel's interview was
transcribed from notes.

A portion of the authors' royalties will
be contributed to New York City
organizations that provide services for
homeless individuals.